TORQUAY
THROUGH TIME
Leslie Retallick

AMBERLEY PUBLISHING

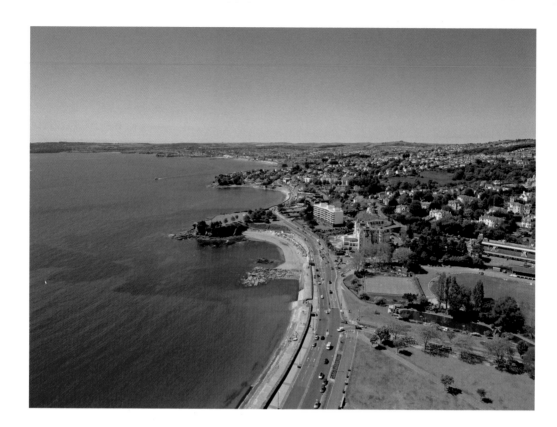

First published 2009

Amberley Publishing Plc
Cirencester Road, Chalford,
Stroud, Gloucestershire, GL6 8PE

www.amberley-books.com

Copyright © Leslie Retallick, 2009

The right of Leslie Retallick to be identified as the
Author of this work has been asserted in accordance
with the Copyrights, Designs and Patents Act 1988.

ISBN 978 1 84868 649 6

British Library Cataloguing in Publication Data.
A catalogue record for this book is available from
the British Library.

Typeset in 9.5pt on 12pt Celeste.
Typesetting by Amberley Publishing.
Printed in the UK.

Introduction

The late Victorians and Edwardians were supremely self-confident people – absolutely sure of their place in the world. Their empire stretched around the globe and its builders and rulers were not given to self-doubt or false modesty. This confidence took on a tangible form in their building and engineering projects as they forged ahead with schemes that would have daunted lesser mortals.

The same was as true locally in Torquay as it was nationally. New promenades, water and sewage systems (much of them still in use today), land reclamation schemes, public and civic buildings and – above all – trees. The bare headlands and scrubby coastal hills of Torquay were an affront to the sensibilities of Torquay's well-heeled residents and visitors, so, in their usual confident way, they set about planting trees to cover the offending areas. And not just a few trees here and there, but saplings in their tens of thousands were planted all along the coast as well as on the more inland heights.

There was plenty of money for the tree planting as, right from its earliest days as a resort at the end of the eighteenth century, Torquay catered largely for the rich and the powerful. The aristocracy loved Torquay, as did both British and foreign royalty – the area's mild winter climate reminding them of their more usual haunts on the French and Italian Rivieras. The continental wars of the Napoleonic era had closed these destinations to British travellers, who perforce were made to look closer to home for their holidays and winter stays – hence the birth of the self-styled English Riviera.

The trees that were planted with such reckless abandon have now reached, and in many cases actually passed, their maturity. Now I think that I ought to make it clear at this point that I like trees. They're a definite plus in the landscape; they add shade along leafy lanes, they introduce a myriad of subtle colours to the countryside and they

provide a haven for more forms of wildlife than you could shake a squirrel at. Torquay would be a much poorer place without them. But when it came to taking the photographs for this book, trees were the bane of my life! A fair number of the old views in this book date from the golden era of the picture postcard, from the late nineteenth century through to 1914. There is a series of views that appear on countless postcards of those times, views which were well known throughout Britain and probably far beyond these shores. But in trying to re-create many of those views today, I was met with a sea of green. Even fighting my way through the outer belts of trees didn't help, as I would find an impenetrable forest beyond. Therefore a certain amount of licence has had to be used at times in this book, and I apologise in advance for the liberties so taken.

The First World War brought a crushing end to the privileged lifestyle of Torquay's accustomed clientele and the town was forced to change gear and move from a winter resort mainly for the rich to a summer resort for everyone. The changes that have occurred since then have in some cases been minor but in others dramatic. Hopefully the pictures that follow will give something of the flavour of those changes.

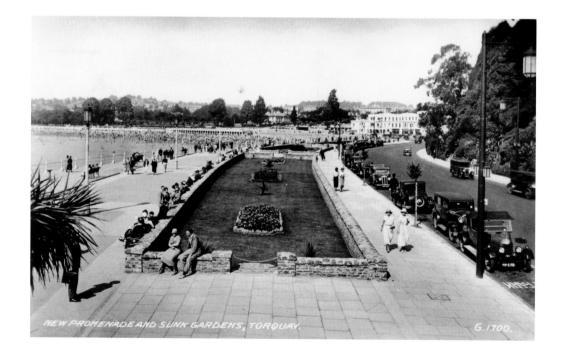

NEW PROMENADE AND SUNK GARDENS, TORQUAY. G.1700.

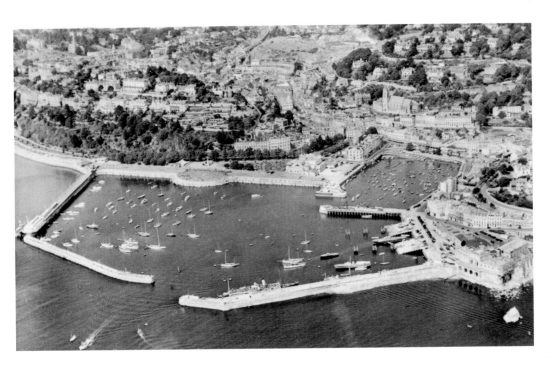

Bird's Eye View

Not having the finances necessary to hire a plane to reproduce the above shot of the harbour (postmarked 1949), I took advantage of a 'flight' in the Hi Flyer Balloon, whose installation on the seafront caused considerable controversy which was still rumbling on at the time of writing. Whatever the pros and cons of the situation, there's no denying the spectacular views obtained when the balloon reaches its highest altitude, some 200 metres above the ground.

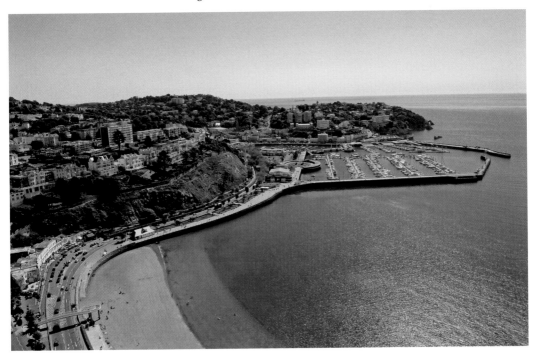

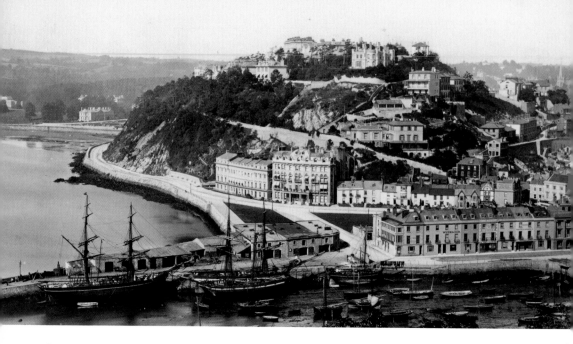

The Harbour from Vane Hill

One of a pair of classic views of Torquay, this shot from Vane Hill shows how much land has been reclaimed from the sea. Most visitors (and probably some residents) do not realise that if they'd tried to walk along the promenade and gardens that now stretch along the seafront they'd have drowned a couple of hundred years ago, as the sea once lapped at the foot of Waldon Hill. Some reclamation work had already taken place by the 1880s, the date of the earlier photograph, but the whole area where the Pavilion now sits, and the gardens beyond it, was still under water.

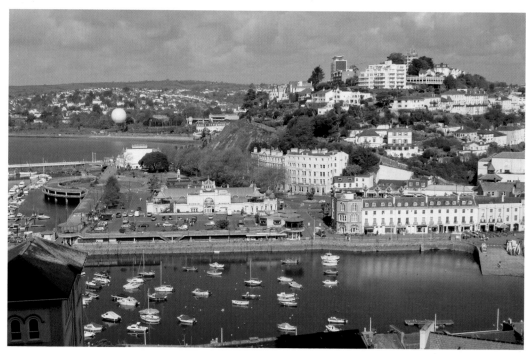

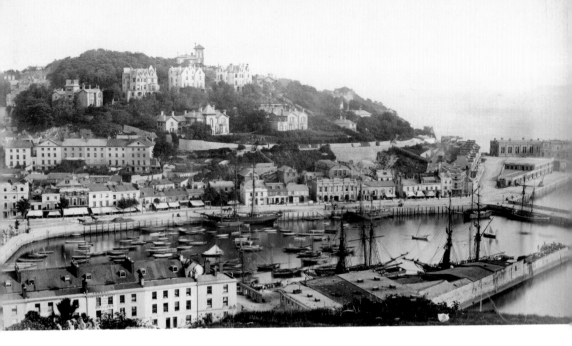

The Harbour from Waldon Hill

The partner to the previous picture is this view of the harbour and Vane Hill from Waldon Hill, taken from the opposite direction. Many of the nineteenth-century houses and villas on Vane Hill have now gone, mostly replaced by apartment blocks. The first of these to be built were the three blocks of Shirley Towers, which were immediately dubbed – and remain – the 'Ugly Sisters'. The later blocks are considerably more sympathetic.

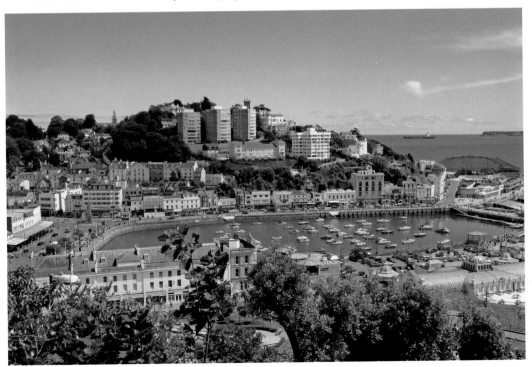

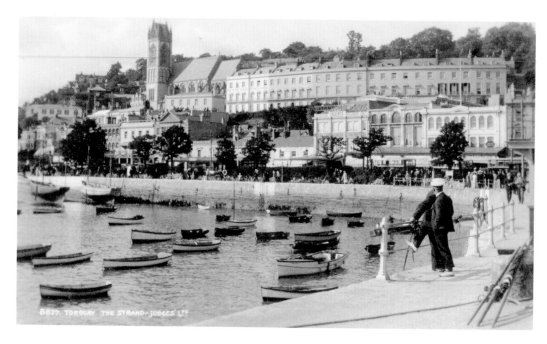

Inner Harbour from Victoria Parade

The surprising thing about this view is how little has changed, especially considering its position in the heart of the town. Some of the buildings along the Strand and the Terrace have grown taller by having extra floors grafted on, but apart from that (and the clothes of the people in the foreground) the views are not so different.

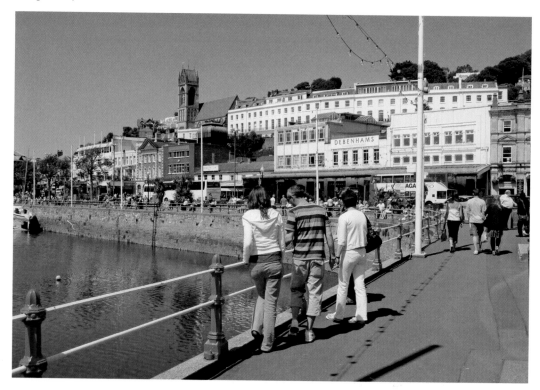

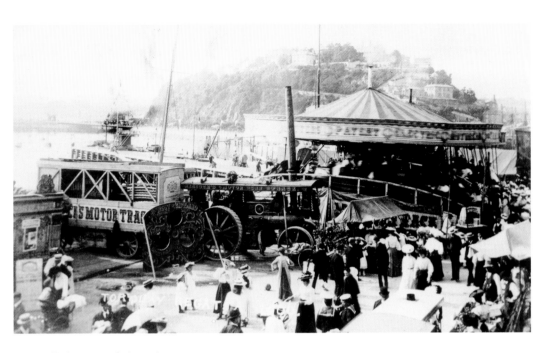

All the Fun of the Fair!

The Regatta Fair used to set up its stalls and sideshows along Victoria Parade and on Beacon Quay. It must have been a terrible hindrance to traffic right from the start and especially once the tram network was built. Eventually, after much negotiation and a war of words in the local paper that would have done credit to a national crisis, the site of the fair was transferred to Torre Abbey Meadows where it currently remains.

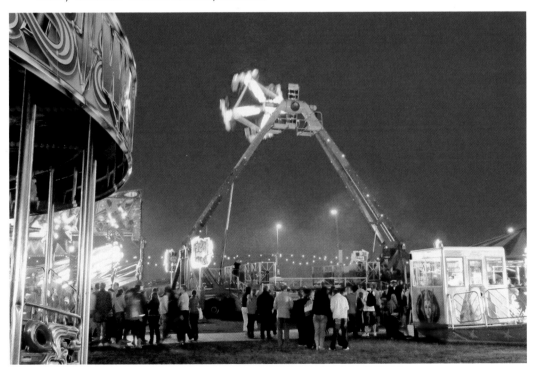

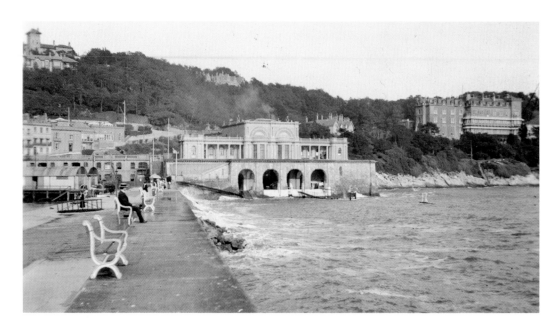

Bath Saloons from Haldon Pier

The arches that supported the Bath Saloons were retained after the building was demolished in 1971 to be replaced by Coral Island. The publicity stated the arches had been carefully preserved but in fact numerous attempts were made to demolish them. The arches stubbornly refused to co-operate and hadn't budged an inch. Eventually it was decided to leave them alone and they stand proudly to this day, even though Coral Island itself has long since gone to the land of unwanted buildings!

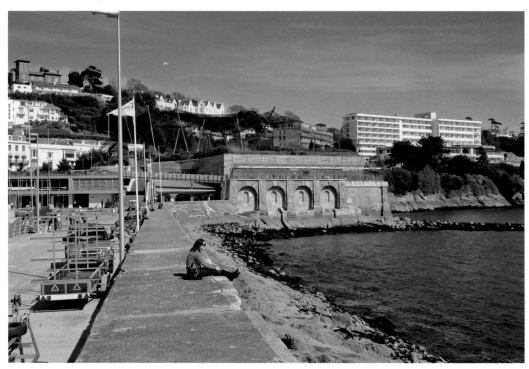

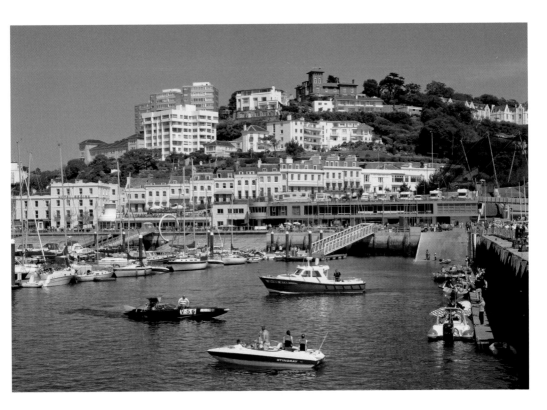

Vane Hill from the Harbour

Pleasure craft dominate today's harbour scene, but a hundred years ago Torquay Harbour was still a thriving commercial port. The warehouses of Coastline Ltd occupied much of Beacon Quay, their vessels calling in with cargoes of wood (mostly from Scandinavia), coal and more or less anything that was needed locally.

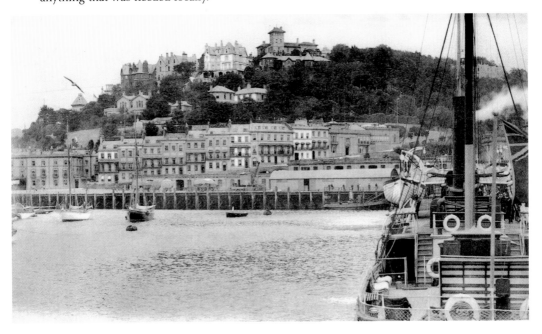

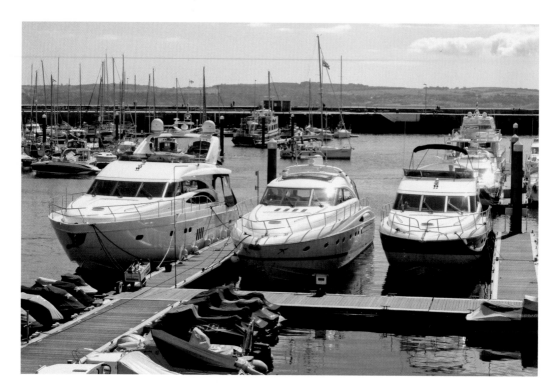

Toys for Boys

Torquay's marina plays host to some people's extremely expensive toys during the summer, when visiting cruisers line up to pose along the pontoons. In spite of the mega-money they must have cost, they simply cannot compare with the sheer elegance of the steam yachts of an earlier era. The ones shown here probably arrived for the annual Regatta, which would explain why they are 'dressed overall' with yards and yards of bunting.

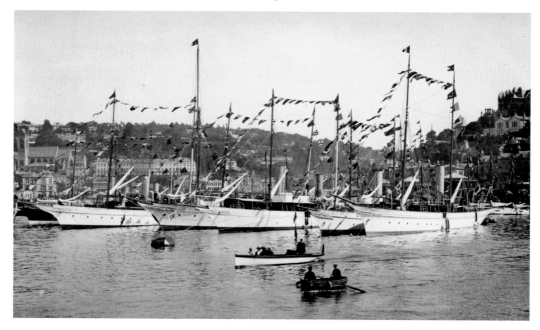

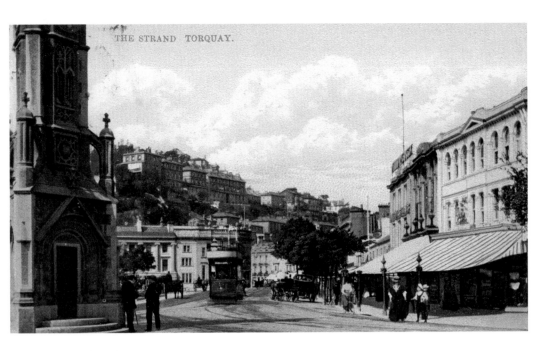

THE STRAND TORQUAY.

Tram and Train

Trams were late in arriving in Torquay – they were considered too 'common' for Torquay's elite – but when they did arrive they proved popular, though not with the elite who had to move their horse-drawn landaus out of the way of the clanking and sparking vehicles. The trams were also rather uncomfortable, rattling and bumping around town. The present day 'land train', seen here trundling along the Strand towards the clock tower, is just as popular – and just as bumpy!

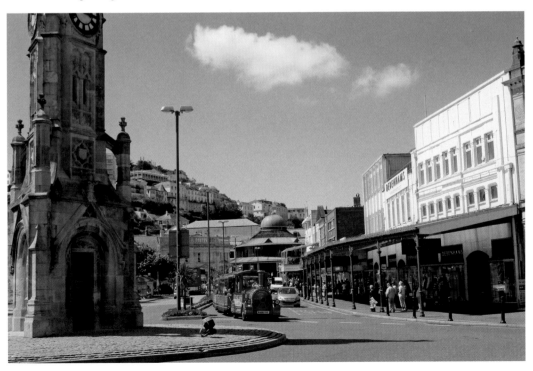

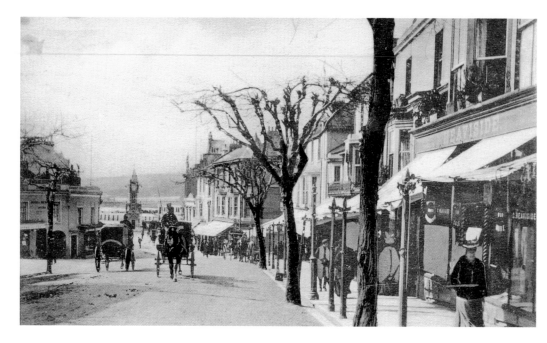

Torwood Street

The winter of 1902, and horse-drawn carriages pass each other in Torwood Street, still recognisable today as there have been few changes. The Heaviside Music Shop on the right (owned by David Heaviside, brother of the famous scientist, Oliver) has been replaced by McColl's Store, and on the extreme left, the grand façade of what was intended to be the Scala Theatre stares proudly up the street. Only the outer walls, complete with ornate statuary, were ever completed.

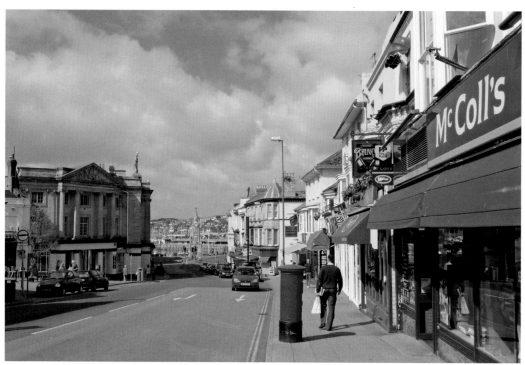

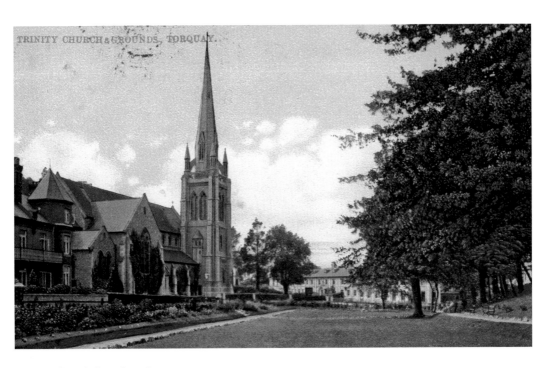

Holy Trinity Church

One of a number of Torquay churches now used for secular purposes, Holy Trinity serves as a play centre for young children and advertises itself as the 'Rainbow Fun House'. Its tower and spire are still supremely elegant, even though the original view from Torwood Gardens is now obscured by the massive bulk of what is currently the AFM Bowling Centre.

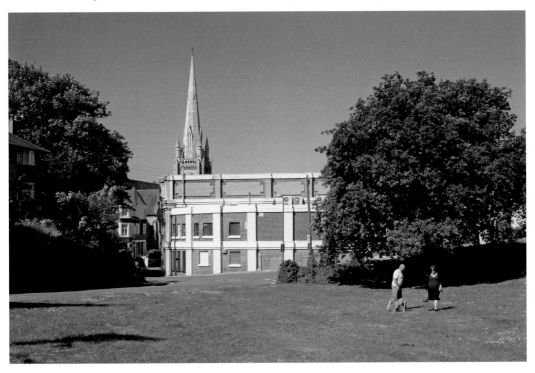

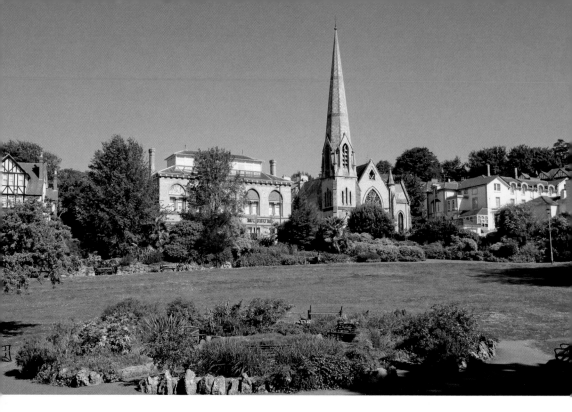

Torwood Gardens

These gardens are unjustly neglected by the majority of visitors to Torquay. Even the steady stream of callers at Torquay Museum, which lies directly opposite the gardens, fails to disturb its solitude. The gardens were certainly more frequently used in earlier years but during the time I was taking this photograph, on a very warm and pleasant morning, I noted a grand total of two adults and one dog walking through the park.

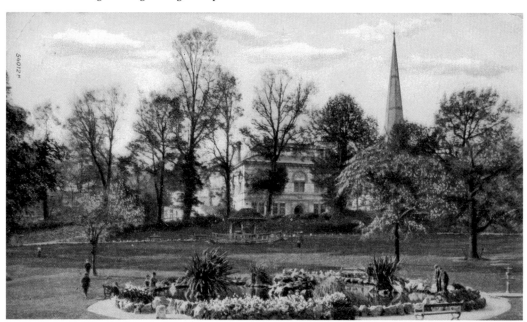

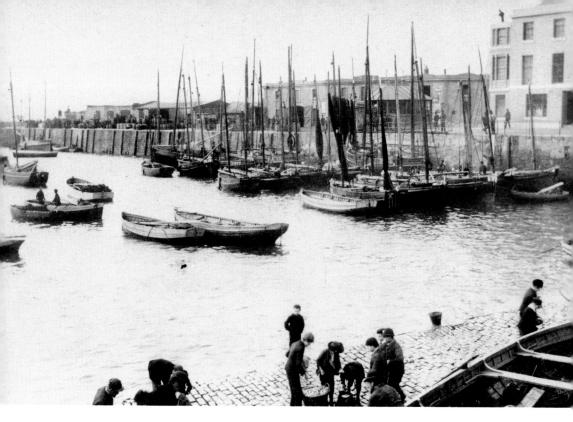

Crabbing

Trying to catch crabs from the slipway in the inner harbour has been a favourite pastime for generations, but in the days when it was a working harbour I doubt any crab with an instinct for self-preservation would have dared set so much as a claw in the harbour's murky waters.

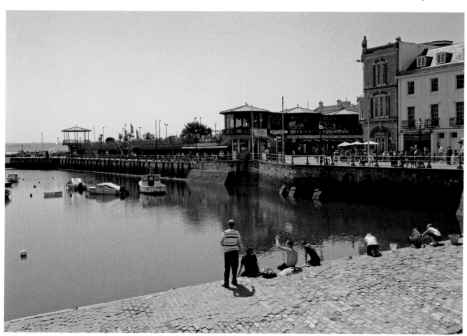

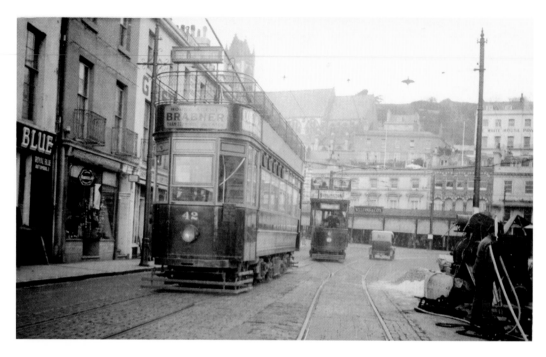

Vaughan Parade

Walking around the harbour side must have been fraught with difficulties in earlier times as it was still a working port and also carried the trams, the tracks for which lined three sides of the inner harbour. Vaughan Parade is now thankfully pedestrianised, making it a very pleasant spot for a stroll or to linger over a cappuccino in one of the pavement cafés.

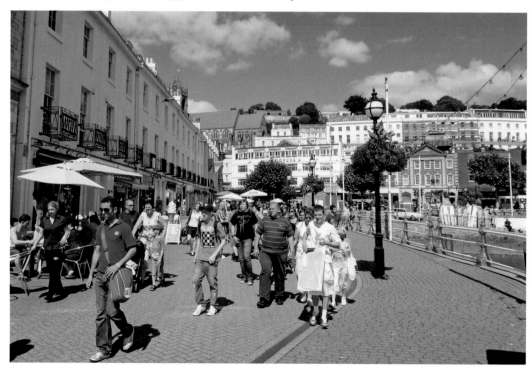

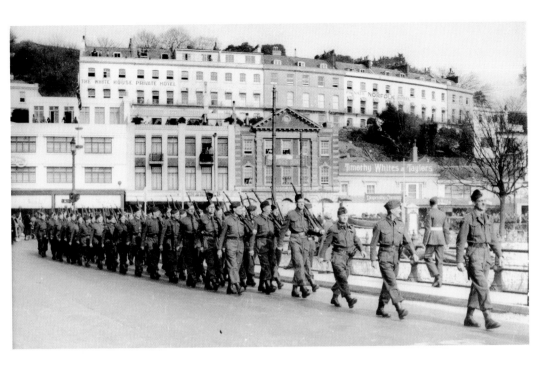

Dad's Army

As a military and naval centre, Torquay was never on a par with Plymouth, but it still saw considerable action during the Second World War. Those in charge thought Torbay might offer a tempting target for a German invasion, so a number of Home Guard units were stationed around the bay, some of which are seen here, proudly marching around the harbour side. Events are often held these days to commemorate the fallen from previous conflicts, particularly by the memorial tablet on Beacon Quay.

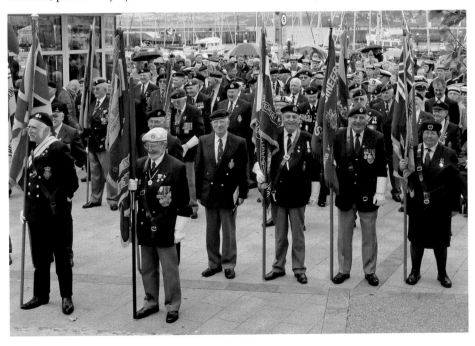

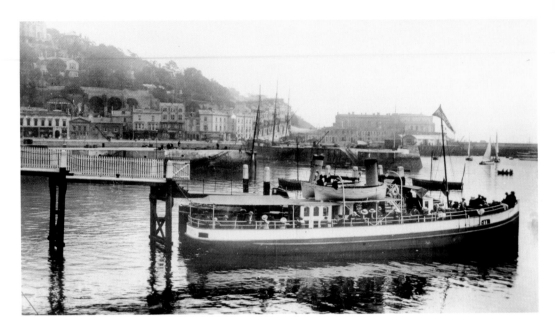

Crossing the Bay

Over the years a number of vessels have plied the waters of Torbay, offering cruises for visitors or a ferry service across to Brixham. In the early twentieth century the SS *Pioneer* ran a regular Torquay-Paignton-Brixham service. There are currently several companies vying for custom, but the longest standing is the *Western Lady* fleet, whose ships have been cruising Torbay since 1946. The current *Western Lady* is number six, seen here disembarking passengers who have arrived from Brixham.

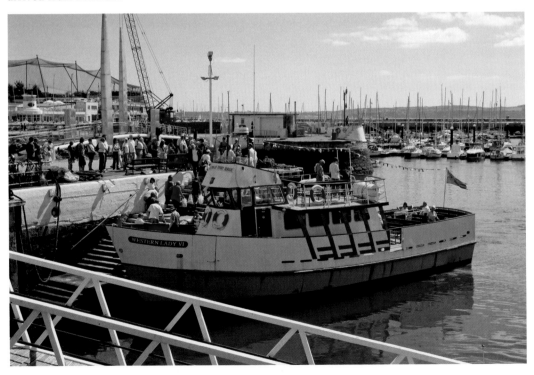

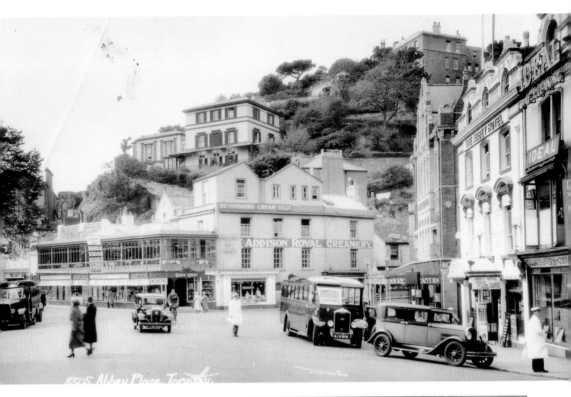

A Souvenir from Torquay

This late 1930's view of Abbey Place
is unrecognisable today, with all the
roadside buildings replaced by the
Fleet Walk shopping parade and the
adjoining Winter Garden and car
park. The message on the postcard
suggests the Second World War was
well under way when it was posted
by a young airman training in
Torquay. 'This is less than a quarter
of a mile from where we are. It
is a nice day, the sun shines over
Torbay. The scenery is delightfully
picturesque but above all is the
shadow of the sergeant. We are
allowed out less at night because of
more intensive training. This I.T.W.
[Initial Training Wing] is shorter
than the rest. We get good food,
fresh air and can parade without
our greatcoats. Thank God. There
is a sunk merchant ship in the
harbour and we are told to expect
air attacks.' He also adds that his
blood group is AA!

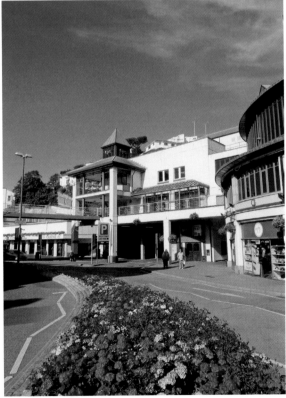

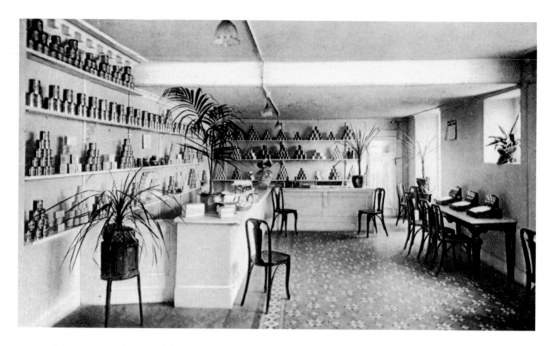

Clotted Cream to Slot Machines

This shot of the interior of the once very popular Addison's Creamery in Abbey Place is so obviously 'posed'. All those tins of clotted cream so carefully arranged on the shelves and even the chairs are precisely positioned. No sign of customers – they would have got in the way of the camera! The whole of the ground floor area is now covered by amusement arcades, just as popular in their own way as the creamery was.

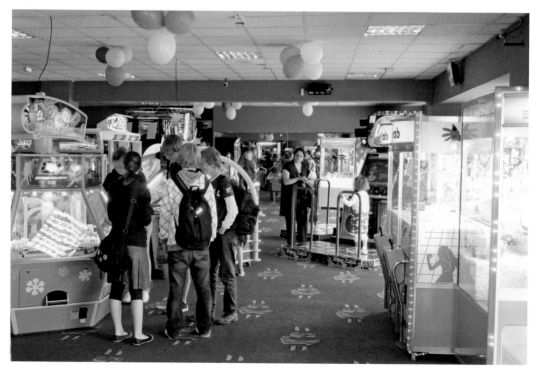

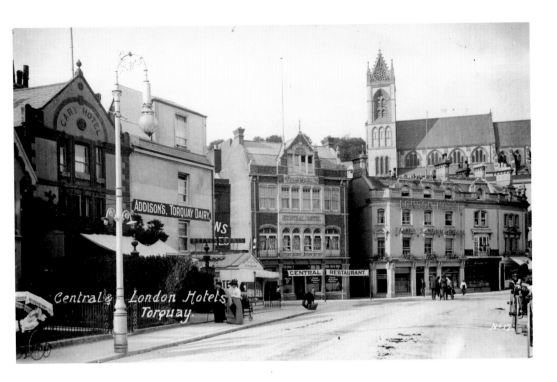

Abbey Place

Only the bulk of St John's church looming in the background remains to show that these two pictures were taken from the same viewpoint. Everything else has been swept away, the Central and London Hotels making way in the late 1980s for the Winter Garden and the entrance to the multi-storey car park. The Cary Hotel on the extreme left of the 1909 view was demolished much earlier when Addison's Creamery was greatly extended.

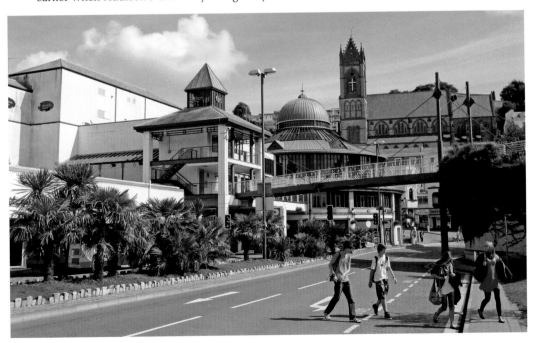

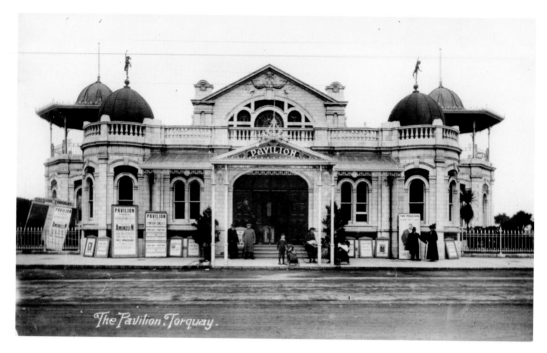

The Pavilion, Torquay.

The Pavilion

In December 1912, only a few months after its opening, the Pavilion was flaunting posters for a forthcoming talk by the Norwegian explorer, Roald Amundsen, the first man to reach the South Pole. Externally the Pavilion looks much as it did when it was first built. It's a delightfully eccentric building but unfortunately still suffers from the phrase bestowed upon it many years ago, describing its architectural style as 'late Edwardian lavatorial'.

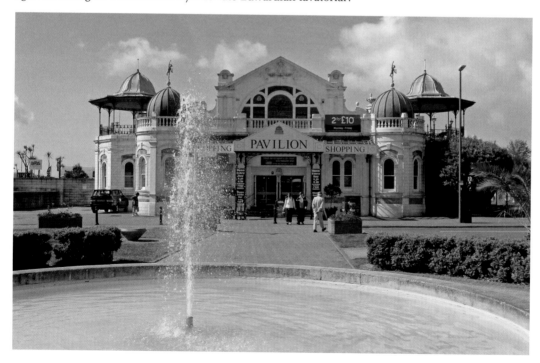

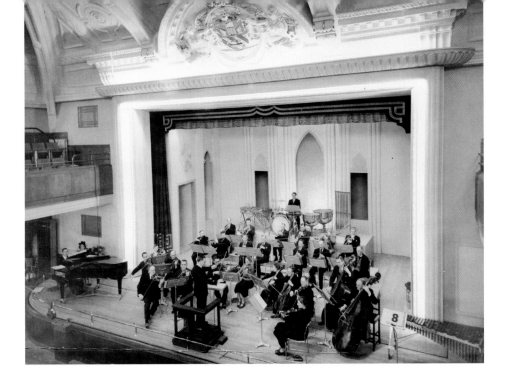

Music Therapy to Retail Therapy

The interior of the Pavilion has been used as concert hall, theatre and skating rink and is currently a shopping centre. Regular concerts by the Torquay Municipal Orchestra, usually under the baton of Ernest Goss after 1920, graced its stage, interspersed with the big names of the music world. Although the decorative ceiling of the interior has been retained, the stage has made way for a new entrance, leaving only the Torquay coat of arms above to divulge where the stars of yesteryear appeared.

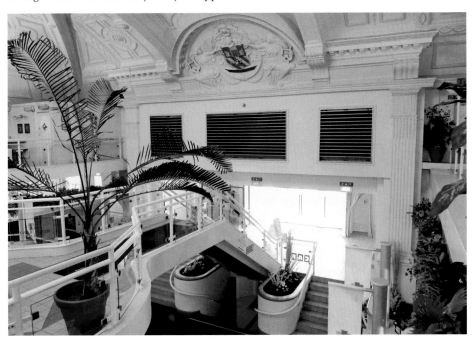

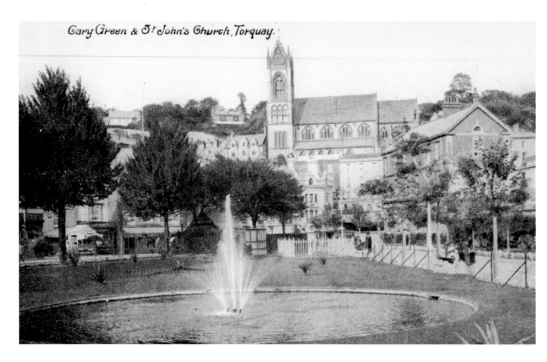

Cary Green & St John's Church, Torquay.

Cary Green

A part of Torquay that actually looks a great deal better today than in times past is the garden of Cary Green. Beautifully landscaped, it's a riot of colour through the spring and summer and makes an attractive focal point on that side of the harbour – even if it is a common sight for the fountains to be covered in foam whenever someone decides that it would be great fun to squirt washing-up liquid into the water.

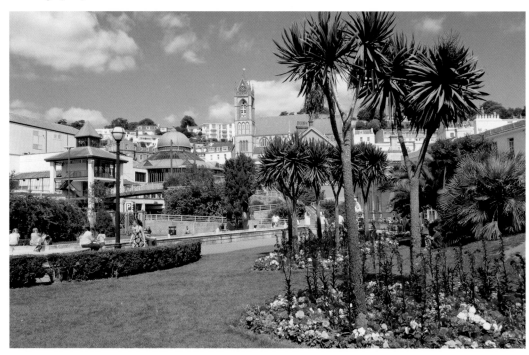

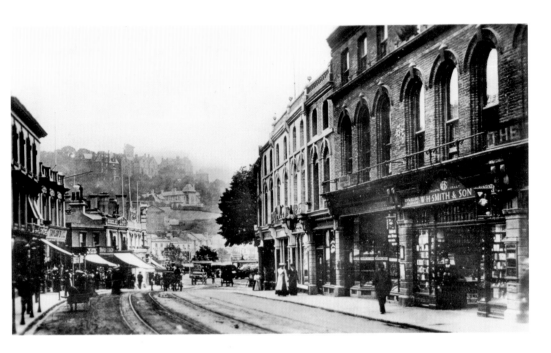

Proceed with Caution

When the nineteenth-century row of shops in what was Fleet Street was demolished to make way for a new development, it was renamed Fleet Walk, presumably in honour of its pedestrianisation. Maybe it should have been called Fleet Jump instead, as buses, lorries, land trains and other sundry assorted vehicles still ply up and down, to the surprise of those who don't realise they are in danger of being mown down.

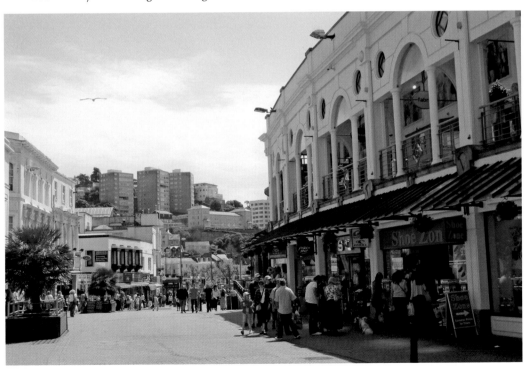

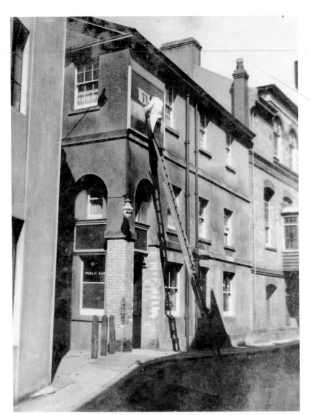

Foresters' Arms

Behind Fleet Walk ran a warren of narrow streets, the main ones (if streets a few feet wide qualify as 'main') being George Street and Swan Street. Run-down and dilapidated, the whole area was swept away in the late 1980s to build the Fleet Walk shopping complex. The Foresters' Arms, which occupied 17-18 George Street, was at one time very popular, but as the area went downhill so did its reputation. Taking a picture from the same location as the original seemed impossible, but, thanks to the shopping centre management, I found the exact spot in the basement – even if all that can be seen now is a service corridor! *Inset: the site of the Foresters' Arms is well below ground level, some distance beyond the rear of the escalators.*

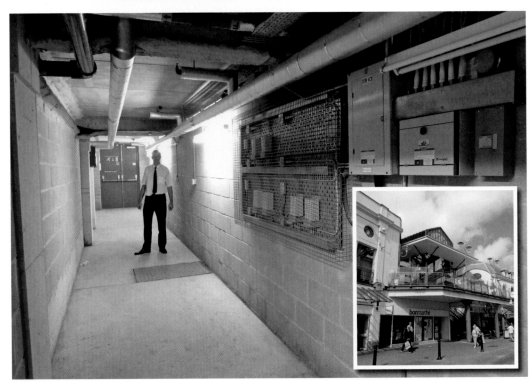

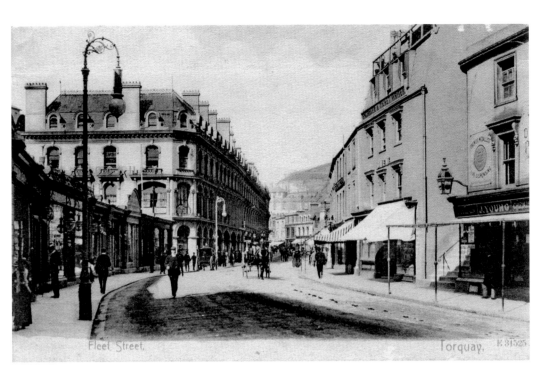

Fleet Walk

The row of little shops on the left has been replaced with the curved façade of Fleet Walk but the rest of the site of the old Fleet Street hasn't changed a great deal. It's rather a shame that the elegant street lamps that once graced the scene have gone, but I doubt they actually gave out much light.

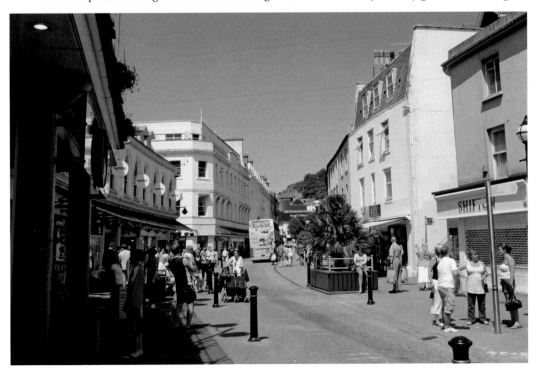

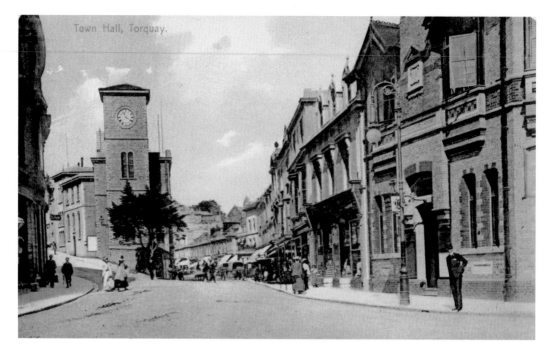

Town Hall, Torquay.

Old Town Hall

Torquay's first town hall opened in 1852. It's rather a grim building, but I suppose the elderly sobersides who made up the Board of Health felt that running a town was a serious business, and therefore needed a serious building to go with it. The other buildings on the right-hand side of the earlier view were demolished to make way for the roundabout in front of the new general post office, itself adapted later as a supermarket.

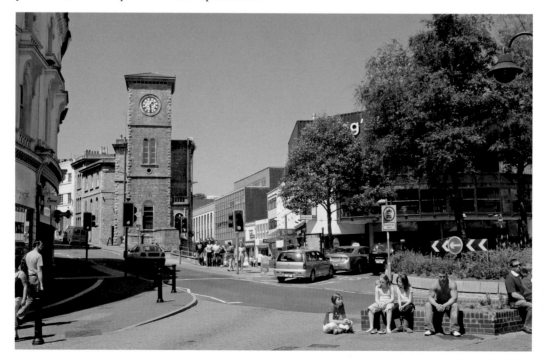

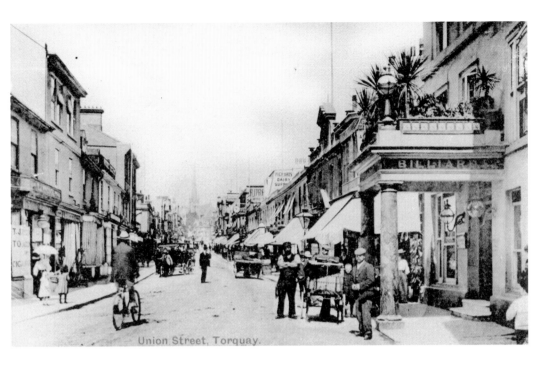

Union Street, Torquay.

Union Street

The entrance of the Union Hotel juts out proudly into the Union Street of about 1900. It had been trading since 1831, but was enlarged before the above postcard was made. Times changed and the hotel was demolished and replaced by shops. The Woolworths store that occupied the site had only recently been closed when the current photograph was taken, but at the time of writing it seems that a national clothing chain will be taking over the empty property.

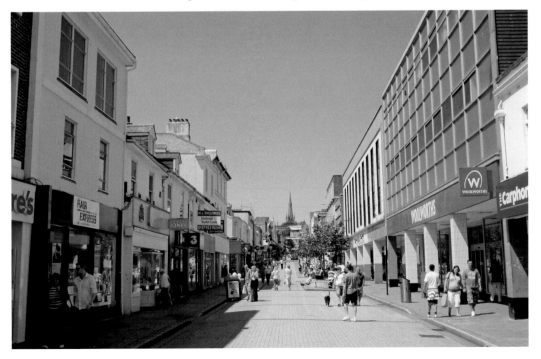

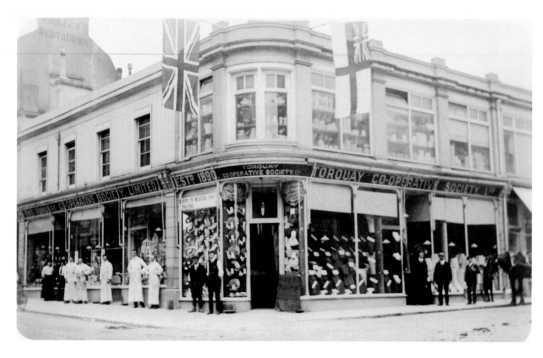

The Co-op

It seems the entire staff of the Co-op stores on the corner of Union Street and what was then Albert Street are posing outside the shop for what was probably a publicity photograph in about 1905. The area was re-developed in 1984 when the Haldon Centre (now Union Square) was constructed, but at least the size and scale of the buildings that front onto Union Street are in keeping with their neighbours.

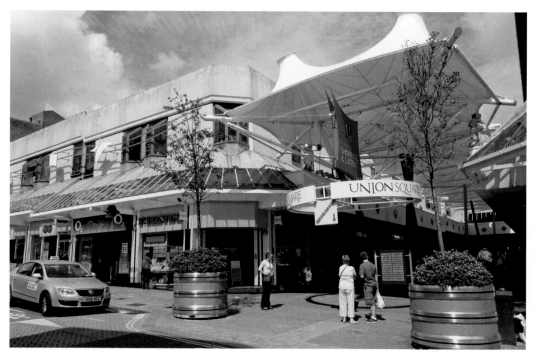

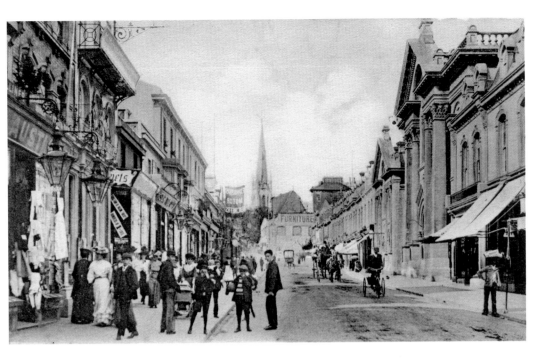

From Prayer to Profit

The Methodist chapel on the right of the above picture is only one of a number of buildings lost between the dates of these two views of Union Street. It was pulled down in the mid-1970s when falling congregations could not afford the sums needed for repair work. Several of the buildings in the row beyond the chapel were destroyed when a bomb landed on them in 1943, flattening several shops and seriously damaging a score of others.

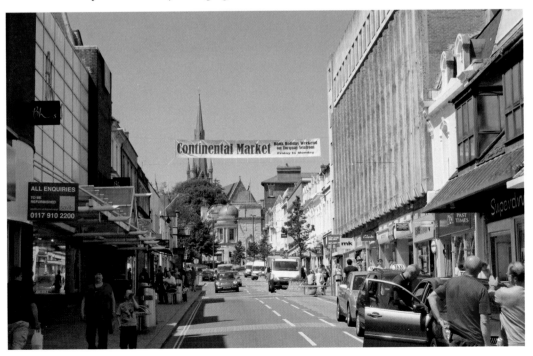

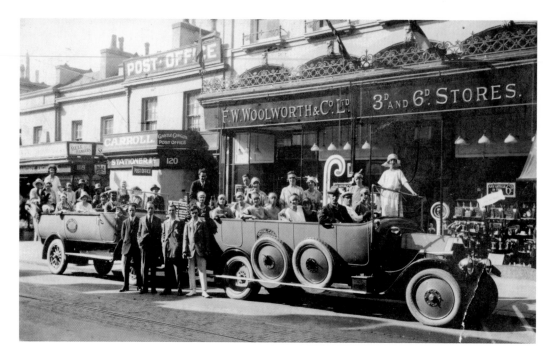

Woolworths at Castle Circus

The wording on this superb postcard of 1923 makes brilliant reading: 'This is Woolworths outing. You can see Ethel standing up in front; she made sure she would be seen! With love, Olive.' Personally I think that Ethel got it right – she deserved to be seen. Woolworths once had several branches in the town; this one was close to Castle Circus but has long since been demolished and replaced with the dreary concrete lump that now houses the Argos store.

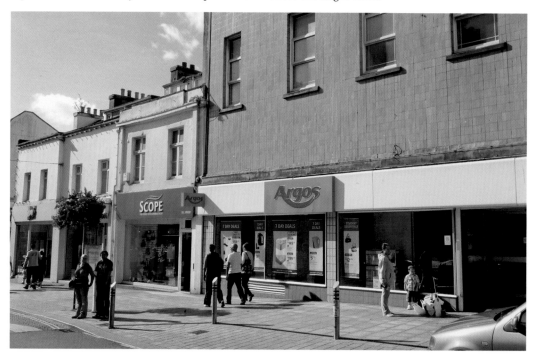

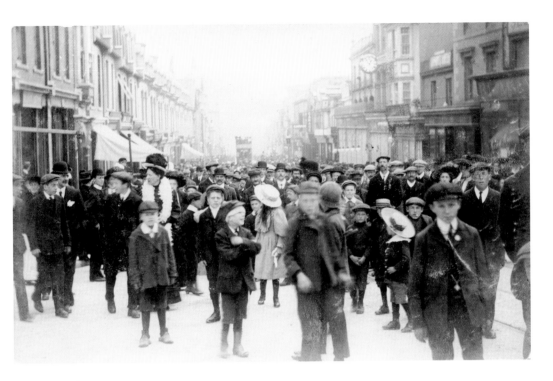

Crowd Scene

What on earth the crowds in the above photograph of the top end of Union Street are there for or looking at I have failed to discover. No doubt the present-day shopkeepers would give a great deal to have crowds of that size wandering along the street, even if they would be in serious danger of being mown down by the traffic that clogs the road from morning to night.

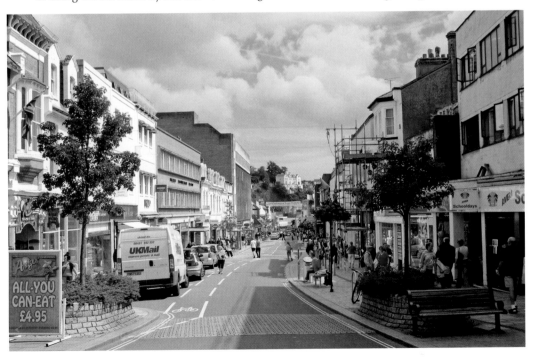

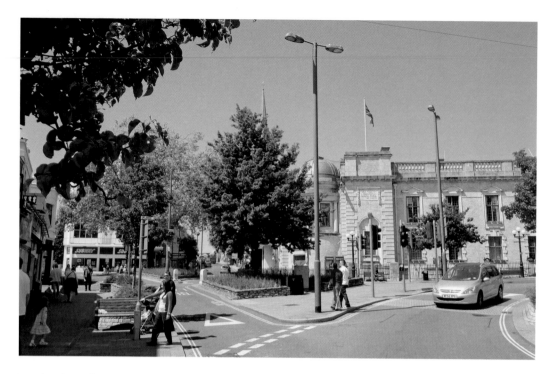

No Castle and No Circus

It's never had a castle (other than a Victorian villa mocked up with a few battlements) and it's never had a circus, but Castle Circus is about as close to a town centre as Torquay can boast. The Carnegie Library can be seen on the right of the old view, taken about 1906, now incorporated into the current town hall, whilst on the left Brocks Furniture Stores has been replaced by Tor Hill House.

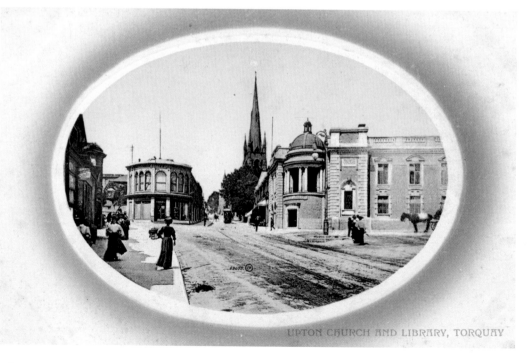

UPTON CHURCH AND LIBRARY, TORQUAY

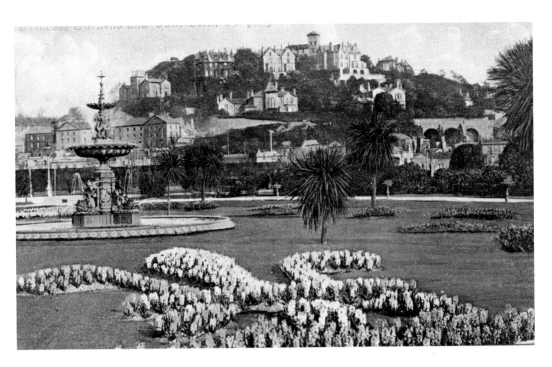

Golden Dolphins

The wonderfully bizarre fountain in Princess Gardens was a gift from Mr H Young, owner of the Torbay Hotel, in 1893. It was presented to mark the construction of the new gardens on land reclaimed from the sea. He obviously felt that it would add just the right finishing touch, even though the local council had to stump up the money for a basin for the fountain to sit in. Mr Young's generosity apparently only went so far. *Inset: detail of the fountain.*

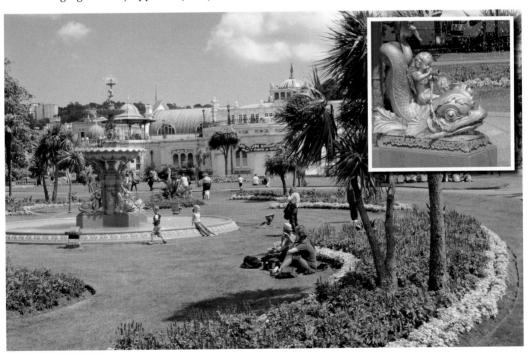

Brassed Off?

Brass bands and the seaside used to go together like fish and chips, and no self-respecting resort would be without its bandstand and its band concerts. Torquay still has the brass band and the concerts, but not the bandstand, nor, sadly, the large and appreciative audiences of yesteryear.

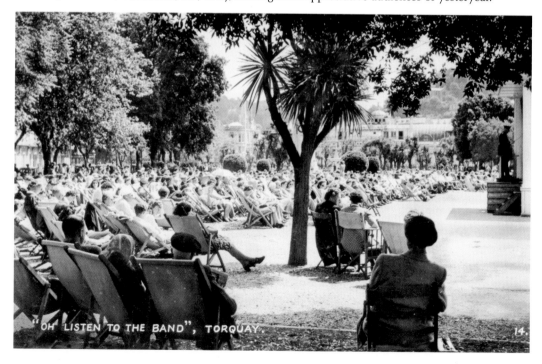

"OH LISTEN TO THE BAND", TORQUAY. 14.

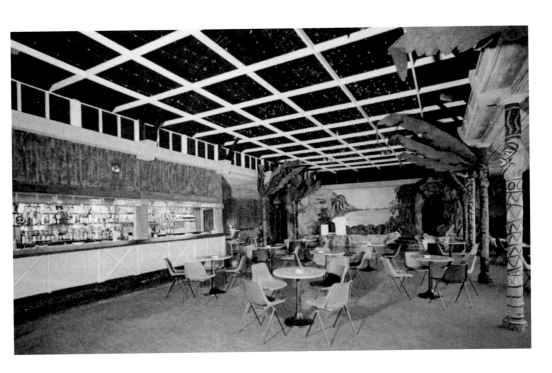

On the Pier

Before the Islander entertainment complex at the end of Princess Pier went up in flames in 1974 (a fate that seems to befall a large percentage of Britain's piers) its Polynesian Bar was a popular draw. Looking at the picture of the bar as it was before the fire, it's difficult to see why, although people were perhaps more easily pleased in those days! Plans have frequently been submitted for a replacement structure, but all have so far come to naught.

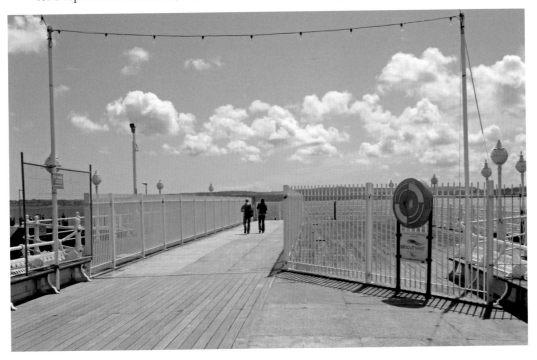

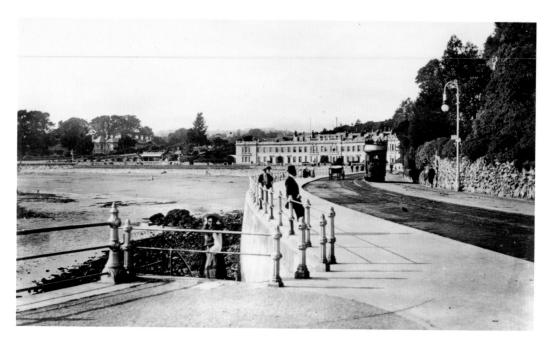

Torbay Road

When the Torbay Road was first built around the base of Waldon Hill in 1840, it was a very narrow affair and prone to continual damage from the winter storms. It was expanded in 1893, but, as shown above, it could not be called wide even then. In the early 1930s a new promenade and gardens were added, giving much needed protection to the road and somewhere away from the traffic fumes for people to stroll.

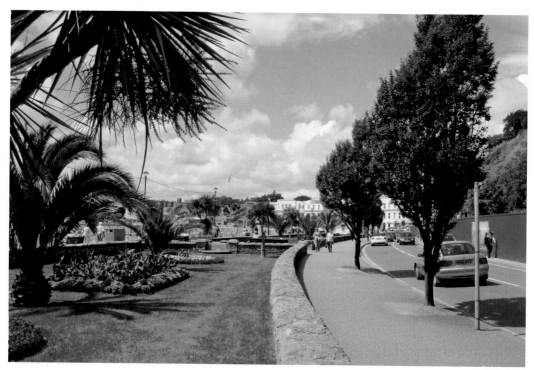

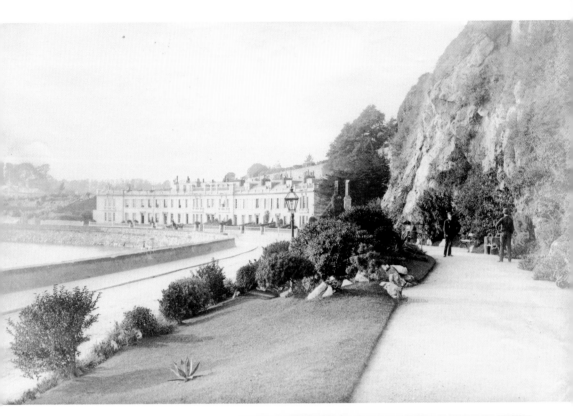

Blooming Marvellous

The Royal Terrace Gardens had just opened when the above photograph was taken in 1893. After years of neglect, the decision was made in 2007 to replant and enhance the whole area. At the time of writing, the entire length of the lower walk has been hidden behind safety barriers for well over a year, whilst most of the lush planting has been removed. On squeezing my way past one of the barriers one weekend (with the intention of taking a shot of some of the construction machinery) I noted this hibiscus in full bloom. I suspect the barriers have protected the area from the weather to such an extent that a micro-climate has been created in that one small part, as I don't think that hibiscus would usually flower out of doors in the UK – even on the English Riviera!

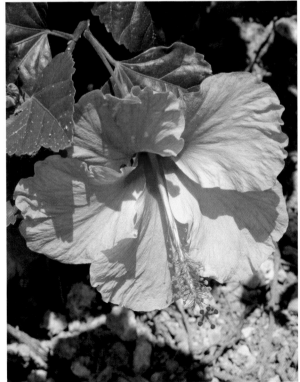

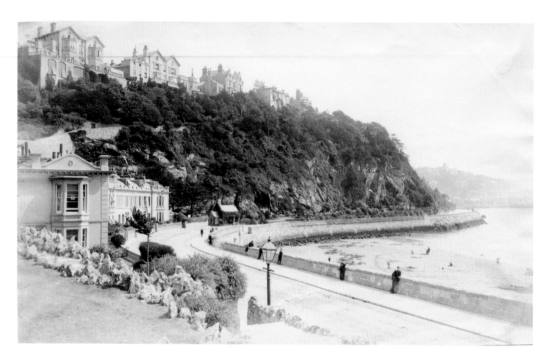

Abbey Crescent

The twin to the previous 1893 view shows Abbey Crescent in the days when it was a fine row of private houses. It's been through a number of different uses since then and is currently the subject of a much-needed re-development scheme, which hopefully will return the area to its elegant best.

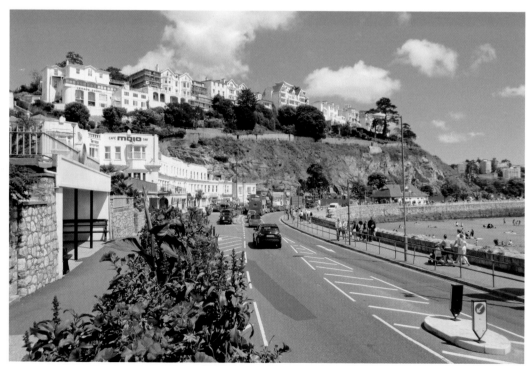

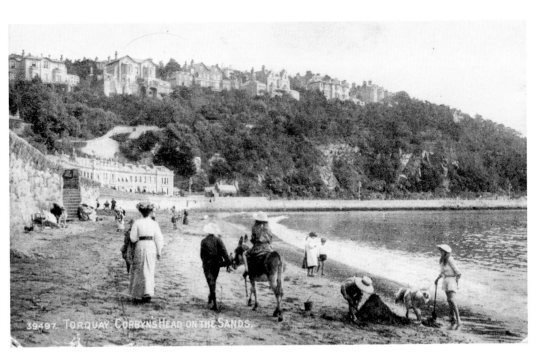

39497. TORQUAY. CORBYNS HEAD ON THE SANDS.

Abbey Sands

Torquay's main beach is Torre Abbey Sands, which suffers in comparison to other local beaches because it submerges at high tide, forcing sunbathers to seek higher ground. Luckily the high tides don't often reach the top of the steps, meaning that the portable refreshment kiosk can stay put for the day, although I guess that Craig Pomeroy and Lee Cullen (who run the kiosk) do sometimes have to scramble to safety with it if a south-westerly suddenly blows out of nowhere!

Belgrave Hotel

Many of Torquay's hotels started life as private houses and have been adapted and extended over the years. The Belgrave was one of a small number that were purpose-built as hotels in Victorian times, hence the larger than usual number of chimneys seen in the earlier shot. Central heating has rendered chimneys obsolete, so there are none to be seen in the present-day photograph.

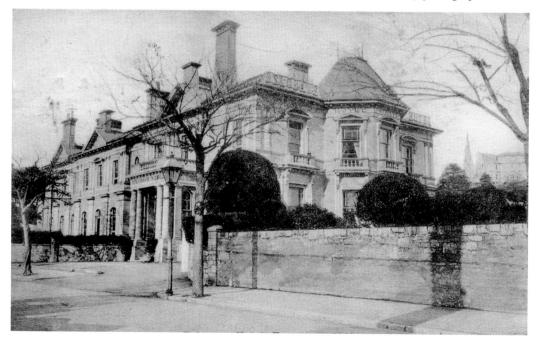

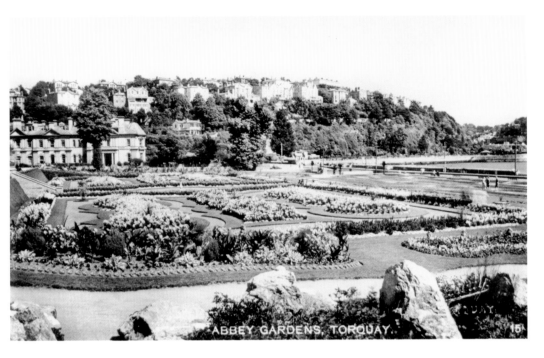

ABBEY GARDENS, TORQUAY.

When is a Palm not a Palm?

Immaculately maintained, the Italian Gardens in Abbey Park haven't changed a great deal since they were laid out in the 1920s, although the palm trees have grown somewhat. I know they're not real palm trees, being a relative of the cabbage family, but Torquay is famous for them and they look genuine enough. To enliven an otherwise dull picture, two members of the council's parks department who were on duty very kindly agreed to pose for the camera!

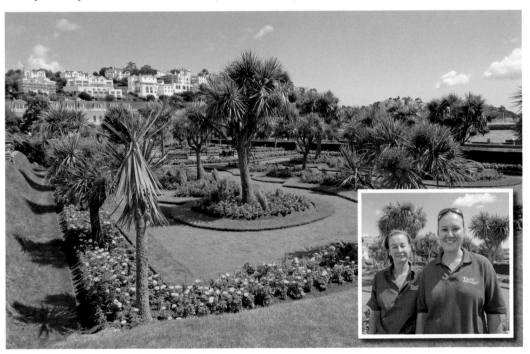

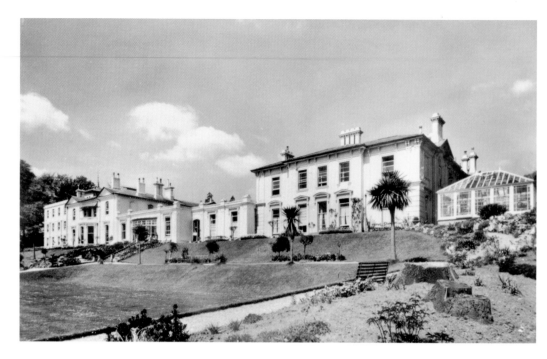

Rosetor and Riviera

Three large villas were built in 1860 on land adjoining Torre Abbey, whose owner, Robert Cary, was strapped for cash and much against his will agreed to the development to raise some revenue. The properties were joined together in 1923 to form the Rosetor Hotel which prospered until the 1970s, eventually being replaced by the Riviera International Centre in 1979. Several members of the centre's staff were kind enough to pose for the camera to add a human touch.

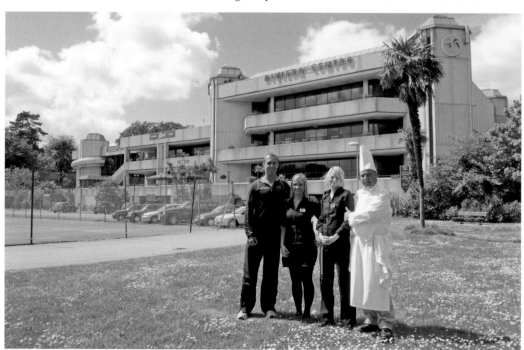

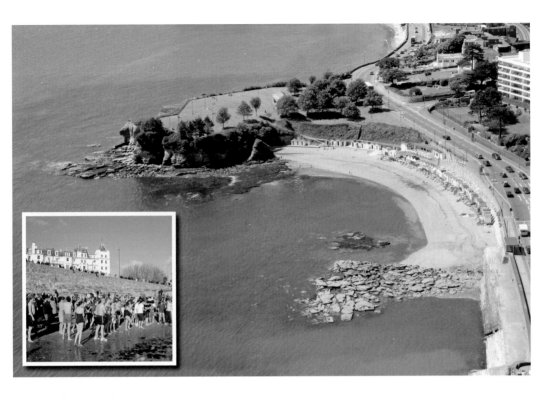

Corbyn Beach

Corbyn Beach (described for some obscure reason as 'Cockington Beach' in the view below of 1908) is probably best known as the venue of Torquay's Boxing Day Dip, when a large number of hardy souls brave the chill waters of Torbay, often to raise money for charity (*inset*). From personal experience I can state that it's not the going in that's the problem – it's the coming back out again!

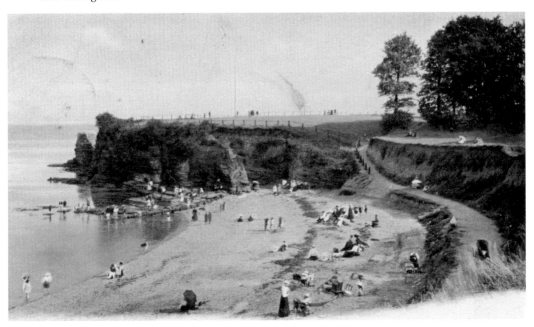

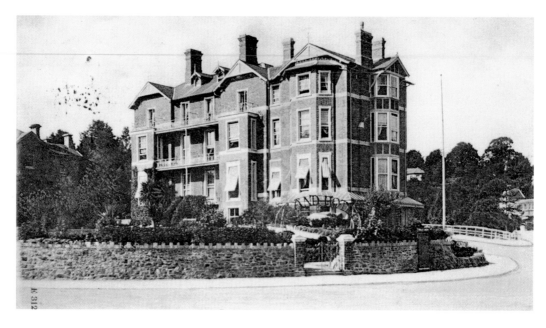

The French Connection

Torquay hotels come in many shapes and sizes: this is the Grand, trying hard to be a French château. It opened as the Great Western Hotel in 1881 with twelve bedrooms, was slightly extended soon after and renamed the Grand Hotel, seen here in the earlier view. Massive enlargements followed, emulating the vogue for French architecture and generating something that wouldn't look out of place in the Loire valley. The original structure is still visible today, though engulfed by the later additions.

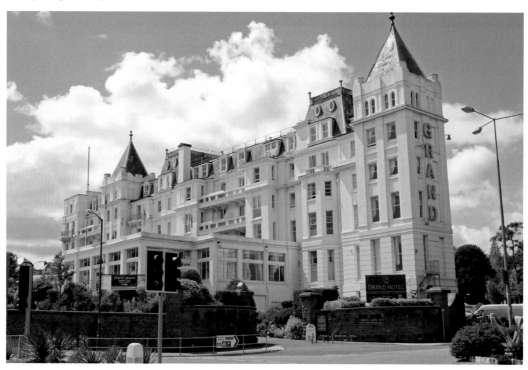

King's Gardens

The gardens between the King's Drive and the recreation ground were opened in 1905 on land leased to the Council by Colonel Cary of Torre Abbey. The lake at the seaward end of the gardens was, according to the council minutes, intended for 'the enjoyment of juvenile yachtsmen', a use it fulfilled for decades. However, it seems that there are no juvenile yachtsmen any more, and the lake is used mainly by the local duck population.

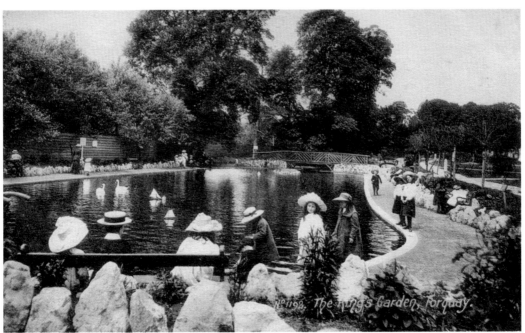

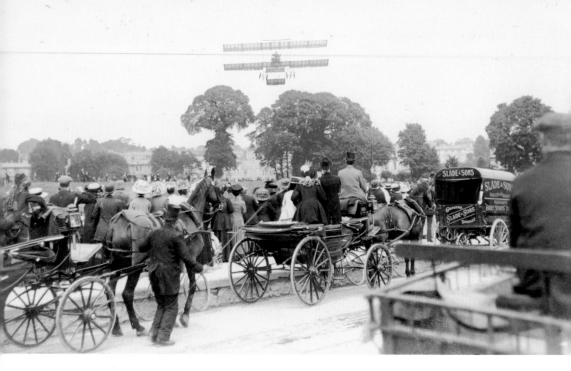

Up, Up and Away

The Meadows were part of the private park of Torre Abbey when Claude Grahame-White took off from there in his biplane in July 1910. Few people had ever seen a plane and applauded rapturously as it spluttered in dismal weather over the warships assembled in Torbay for the Royal Review. Similar lowering skies greeted the spectacular arrival of the Red Arrows in August 2009, but it takes more than bad weather to deter the 'Arrows', and they too received a great welcome.

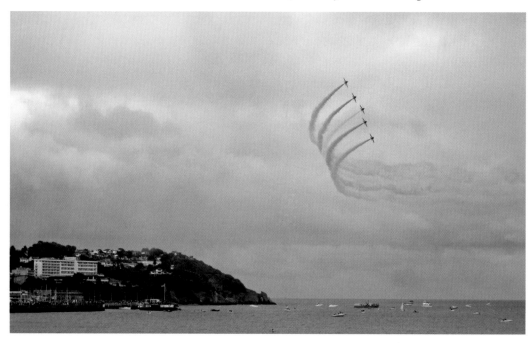

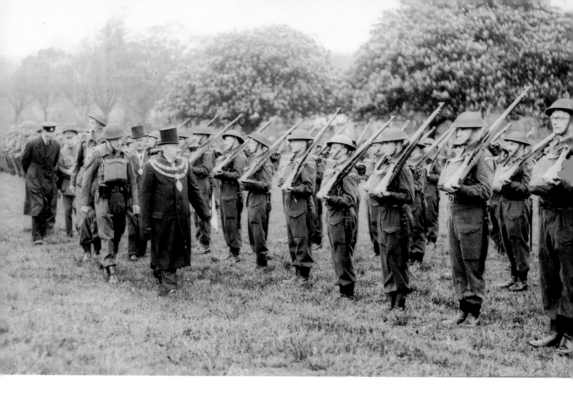

War and Peace

On a soggy Sunday afternoon in 1942, the Mayor of Torquay (Alderman R. J. Bulleid) reviewed the troops at the Battalion Parade of the Home Guard on Torre Abbey Meadows. Sixty-seven years later the Pedal Car Grand Prix was being held in the same place, luckily in different weather, with teams battling to race round the Meadows, many of them adopting fancy dress to enliven the scene.

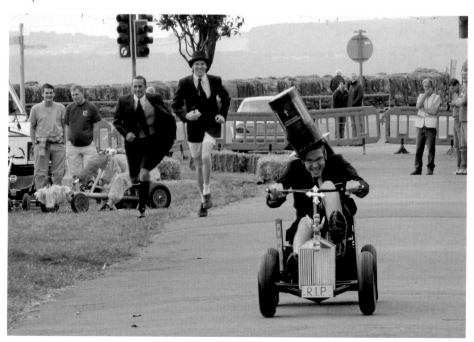

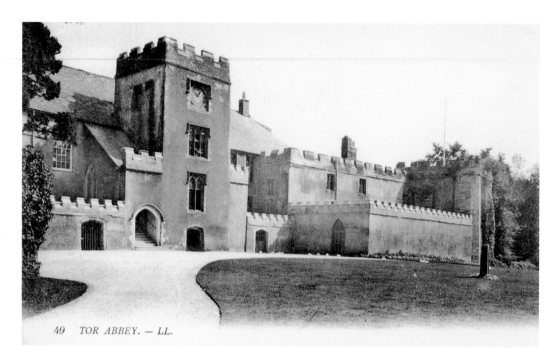

49 TOR ABBEY. — LL.

Torre Abbey

Founded in 1196 by canons of the Premonstratensian Order (and try saying that after a night out), Torre Abbey has been monastery, private house, civic centre and public showcase. The Abbey is currently going through a major transformation as the result of a lottery grant that should ensure its survival into the twenty-second century.

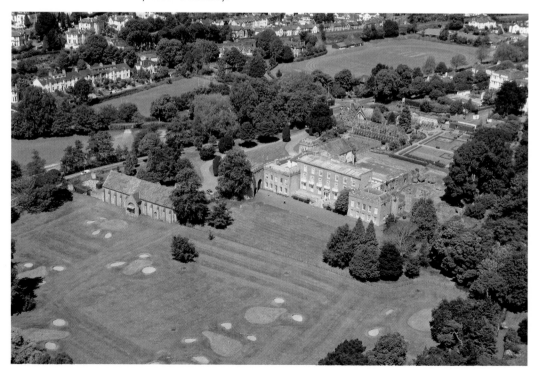

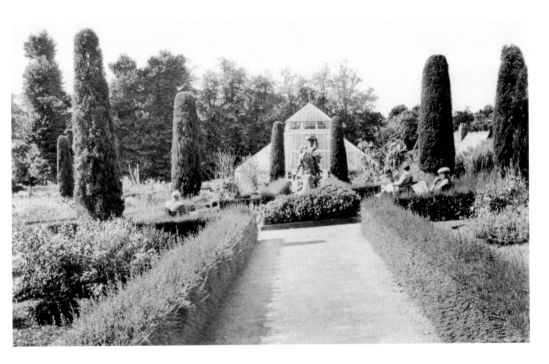

Torre Abbey Gardens

The walled garden to the rear of Torre Abbey opened to the public in 1930 and the Palm House was added in 1939. For many years it was one of the largest in the country, but was replaced in 1969 by the current glass and aluminium structure. The gardens, although still beautifully maintained, have had to be greatly simplified in design, as the intensive labour needed to care for the former elaborate planting can no longer be afforded.

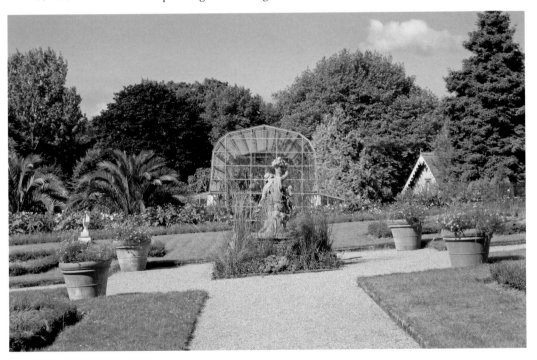

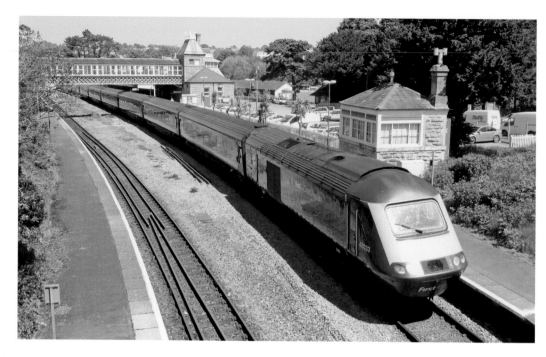

Torquay Railway Station

The station stands in a splendid but isolated position above the main beach, a hefty walk from the town centre. The Cary family of Torre Abbey objected to the railway crossing their land so the line follows the estate boundary. The original plan required a tunnel under Chapel Hill and the track running down the course of Union Street and Fleet Walk to the harbour. Ghastly thought! The station buildings have changed little over the years though the track layout has been greatly simplified.

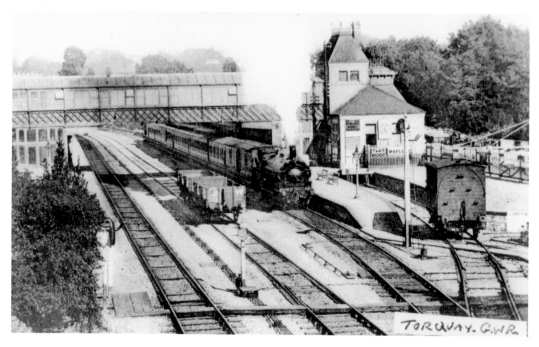

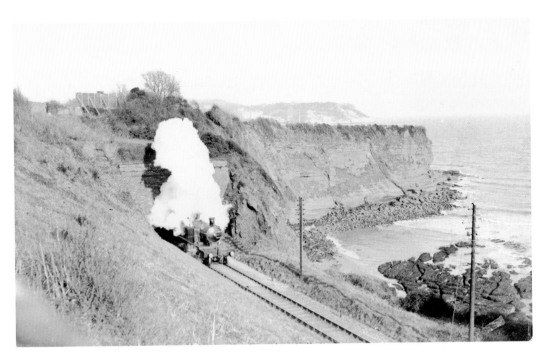

Hollicombe Tunnel

When the railway line was extended to Paignton in the 1860s, it passed through a tunnel under the hill behind Hollicombe beach. This proved to be an expensive bottleneck when the line became busier, as the tunnel was too narrow for a double track, causing long delays. The decision to replace the tunnel with a cutting was finally made in 1908, although it took two years to complete the work.

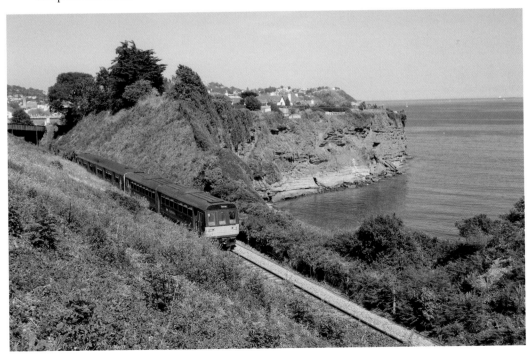

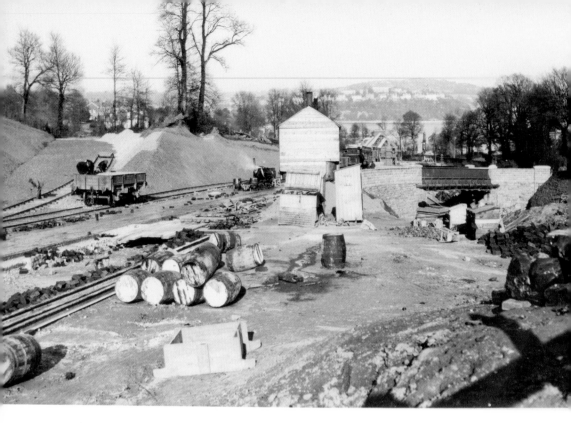

Wheatridge Lane

The road from Torquay to Paignton ran over the top of the Hollicombe tunnel, but it had to be realigned and a bridge built when the tunnel was removed. The early view (taken in 1909) shows the new bridge in position and the new approach to Wheatridge Lane on the left. The temporary railway tracks on the site of the new road belonged to the contractor.

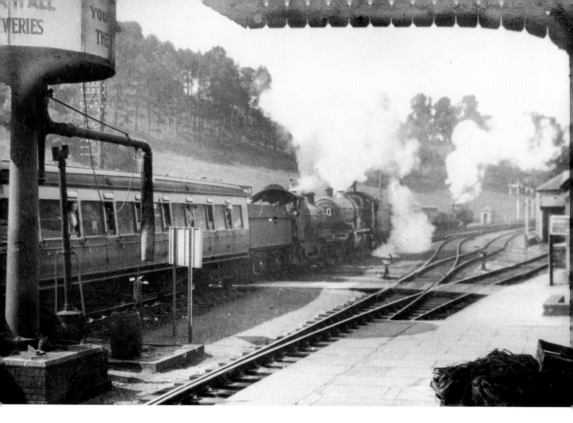

Torre Station

Whilst the argument raged about which route the railway line should take into Torquay, the temporary terminus was at Torre. Although superseded by the new Torquay station, it was still busy right through until the 1970s. These days only a handful of local trains deign to stop, most services roaring through without a second glance. Much of the station building is currently used as a furniture showroom by the Oak Loft company.

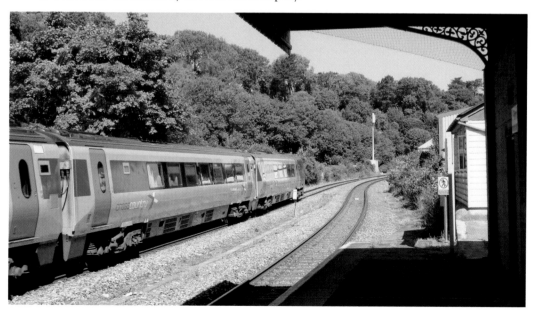

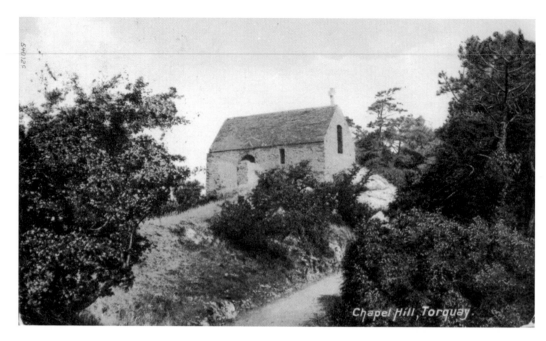

Chapel Hill

St Michael's chapel, perched precariously on the edge of a cliff, dates from the thirteenth century and presumably belonged to Torre Abbey, but what purpose it served is not clear. Tales have circulated over the years, the most common being that a tunnel connects it to the Abbey. I only wish this were true as it would be much more fun. Sadly, the chapel is in a worse condition now than it has been at any time in its history.

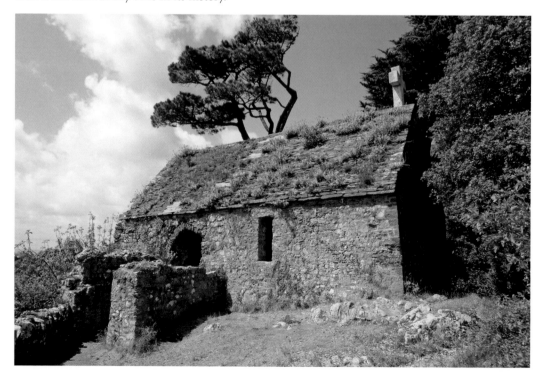

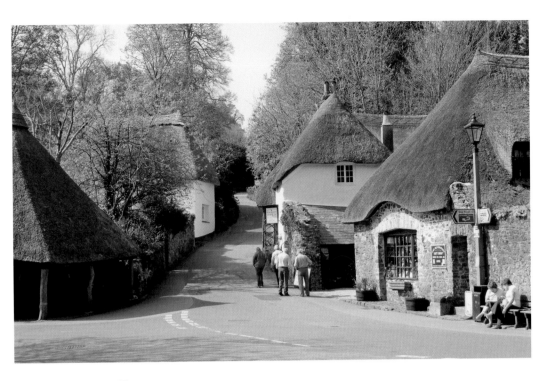

Cockington Village

Cockington's air of timelessness is not as genuine as may be assumed. The original village stood in full view of Cockington Court. When the Revd Roger Mallock inherited the estate in the nineteenth century he didn't care for this set-up and demolished all the buildings that blocked his view of the park, with the exception of the church. A number of cottages were rebuilt near to the old forge, thus giving the village a new centre.

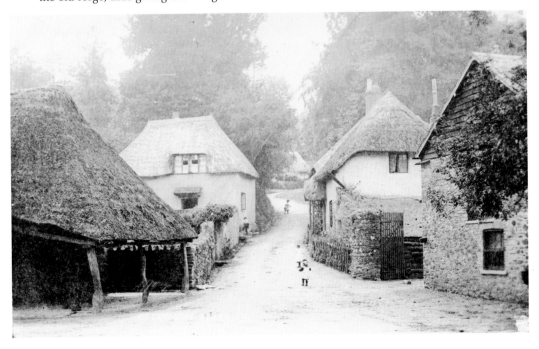

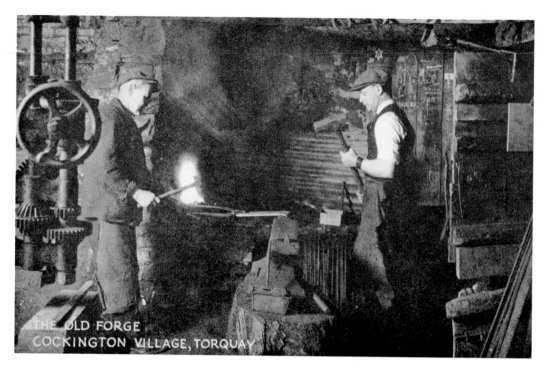

Cockington Forge

The oldest building in the village, the forge at Cockington was still a working affair when the original photograph was taken. Although brave attempts have been made from time to time to bring it back into use, it seems that, sadly, its destiny lies in selling souvenirs to visitors.

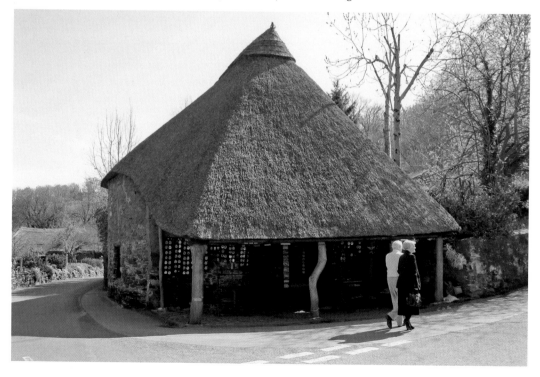

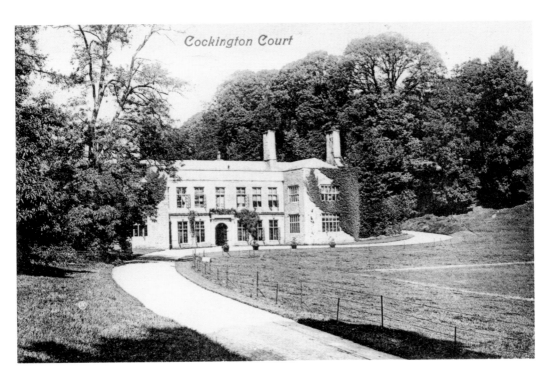

Cockington Court

Howzat!

Still a private residence when the first view was taken, Cockington Court is now a publicly owned showpiece, a situation that would no doubt have caused several generations of the former Mallock owners to throw up their hands in horror. The local cricket clubs now play in front of the court on what must be one of the most dreamily perfect settings for a pitch in the country.

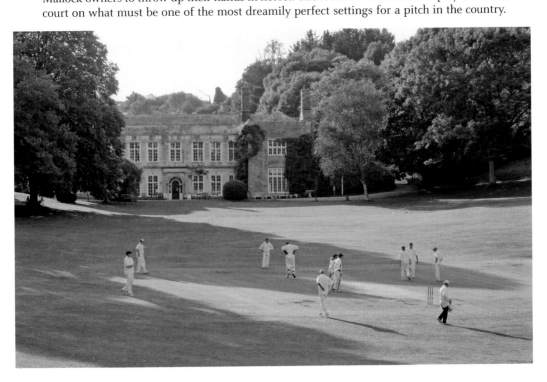

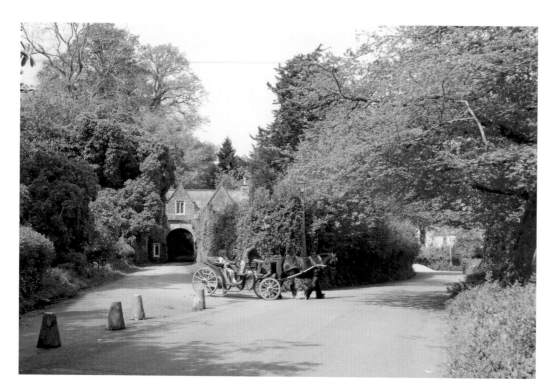

Lower Lodge, Cockington

The Lower Lodge of Cockington Court is totally overwhelmed in spring by a rhododendron that evidently doesn't know its place. The horse-drawn carriage in the present-day photograph has just driven under the lodge arch, bringing holidaymakers from the court back to the village centre.

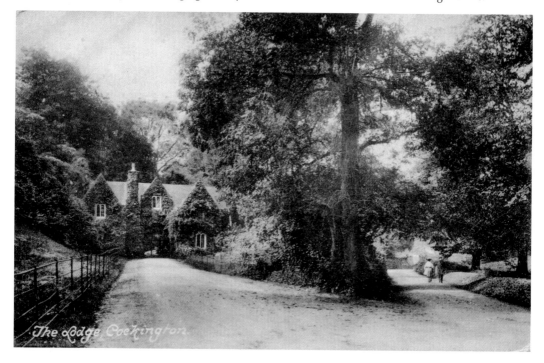

The Lodge Cockington.

Vicarage Hill

The track leading to the right off Vicarage Hill (formerly part of Cockington Lane) once led to a farm and then became a drive leading to Cockington vicarage. The vicar has to make do with rather more humble accommodation these days, and the drive now leads to a private house.

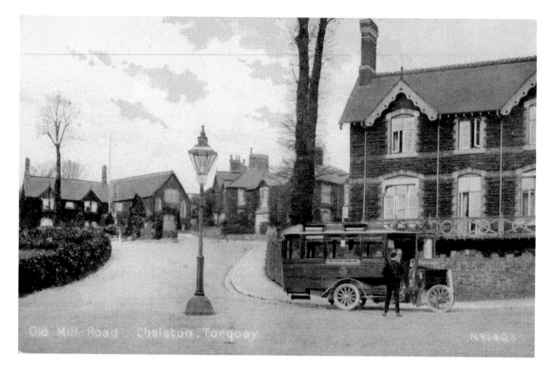

Old Mill Road

One of the four Clarkson Steam Buses, which used a paraffin burner to heat the water, waits at the Chelston terminus on the corner of Old Mill Road and Mallock Road in 1908, shortly before the service to St Marychurch was withdrawn. The lamp standard in the middle of the road must have been a traffic hazard even then and has long since gone, though most of the rest of the scene is little changed.

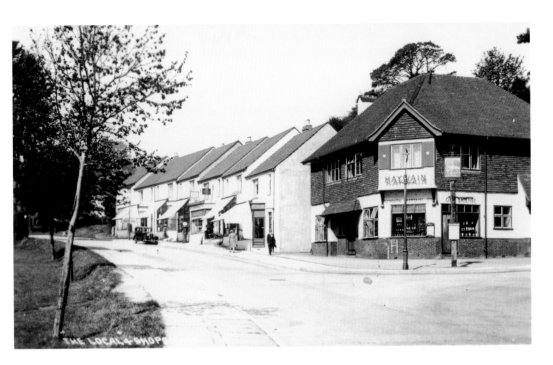

Sherwell Valley Road

The publishers of the above view must have hoped that locals would flock to send images of the nearby shops and pub to their friends, but I can't imagine they sold many copies. The older view dates from the late 1940s but the Haywain Pub and the shops were already ten years old by then. Apart from the tree growth, there's not a great deal of change between the two views.

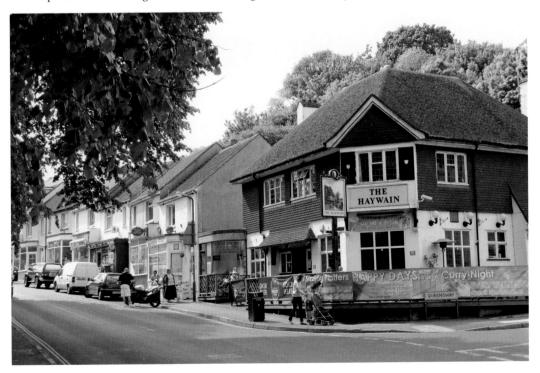

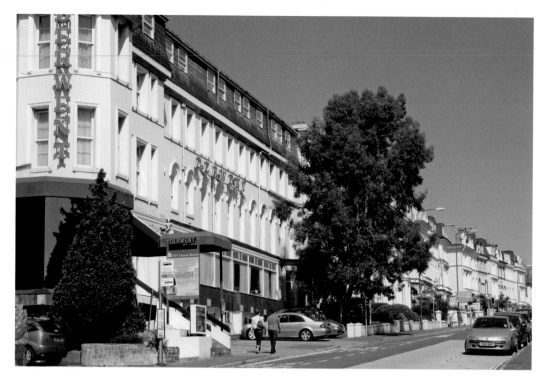

Belgrave Road

Most of Belgrave Road is now filled with guest houses, apartments and hotels, the smartest and highest priced (not unnaturally) being those closest to the seafront. They weren't originally built as holiday accommodation, and much of the road consisted of rows of rather grand houses for the gentry.

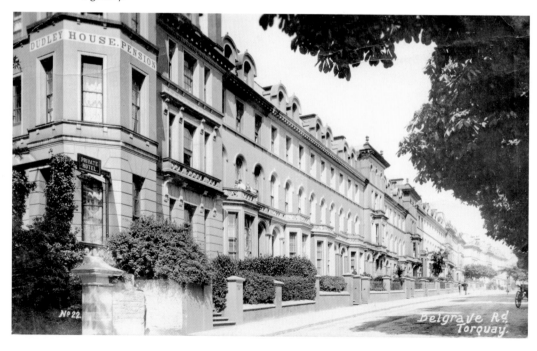

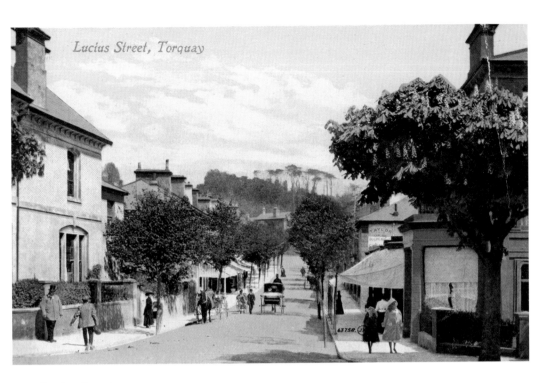

Lucius Street, Torquay

Lucius Street

Lucius Street is still a popular shopping street today, as it was when it was cut in 1862, and, named after Sir Lucius Cary who died in 1643, fighting for the King during the Civil War. Modern transport needs meant that the double row of trees that once graced its length had to be felled, but the street is otherwise not too different now to 1912 when the earlier picture was taken.

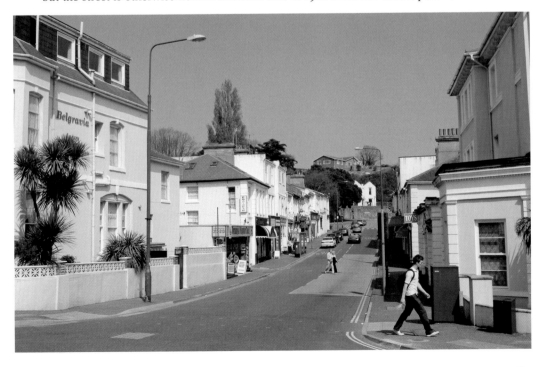

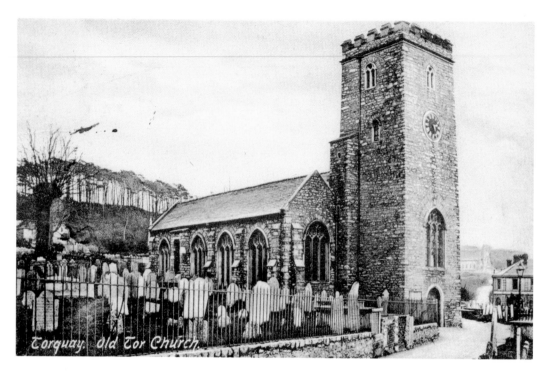

Anglican to Greek Orthodox

Tor church, the original parish church for Torquay (now used by the Greek Orthodox community), is little changed today compared with its appearance in the postcard of 1905. The railings that surrounded the churchyard have gone as have the gravestones, which were tidied up when the area had a makeover some years ago. However, the churchyard has since gathered the sad evidence of two World Wars with its 'Field of Crosses', a grim reminder of terrible times.

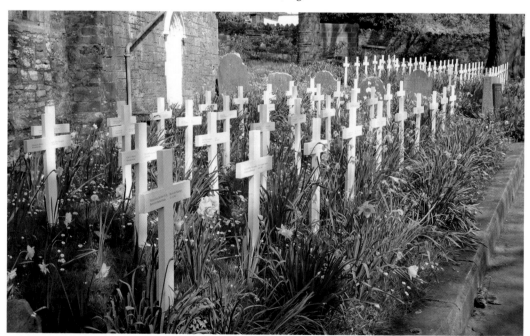

Palatial Policing

The cottages in the above view of 1937 were pulled down to make room for Torquay's rather ostentatious police station. It was built in a tearing hurry in 1944 when such things as planning permission weren't given too much attention, probably the only reason why such a lump of a building was allowed. It's been redesigned in the past few years by lowering the height and adding curved glass and steel, which has softened its appearance.

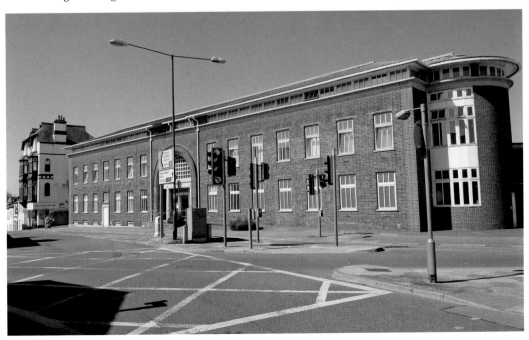

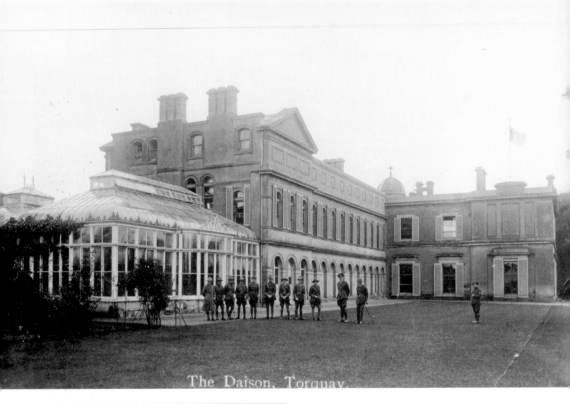

The Daison, Torquay.

The Daison

Torquay doesn't have the best of reputations for looking after its great houses, one of the most opulent of which was The Daison, a sumptuous mansion in the Italianate style, surrounded by 36 acres of gardens and parkland. It was built for the Potts-Chatto family in 1850, but the estate was sold off in separate lots in 1920. The streets of houses that replaced it were given the somewhat uninspired names of First Avenue, Second Avenue, and so on. The only reminder of the former splendour of one of Torquay's grandest houses is the classical-style lodge that survives on the corner of Chatto Road and Main Avenue. Where the great mansion itself stood is a pair of plain semi-detached houses (*inset*).

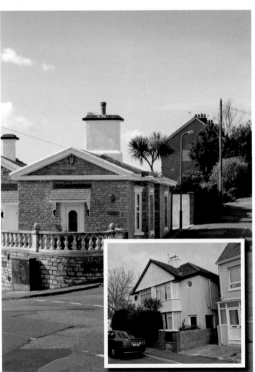

View from Windmill Hill

To photograph the present-day view of this scene meant clambering through the jungle on Windmill Hill to reach the original viewpoint. Even then I had to put the camera on an extending tripod, set the self timer and hold the tripod as far above my head as possible, hoping for the best. The resulting shot shows the junction of Teignmouth Road and Westhill Road, with Cuthbert Mayne School now standing in what were empty fields at the end of the nineteenth century.

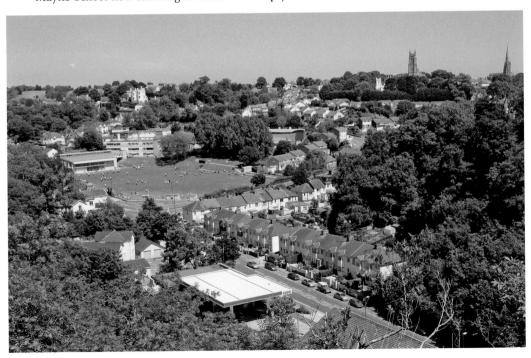

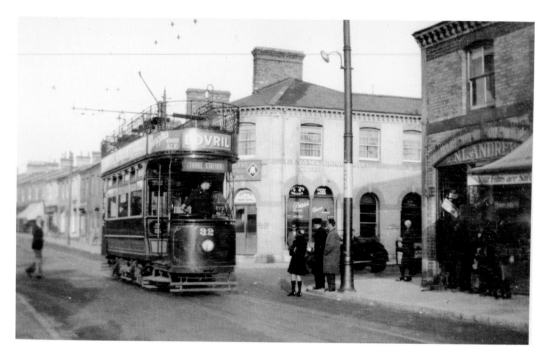

Plainmoor

In 1933, tram no. 32 trundles past the Plainmoor shops in St Marychurch Road on a service to Torre Station. Apart from the loss of the trams little has changed in the nearly eight decades between the two shots. The Union Hotel is still trading, albeit as the Union Inn, and there are more shops now than there used to be, but that's about it as far as changes go.

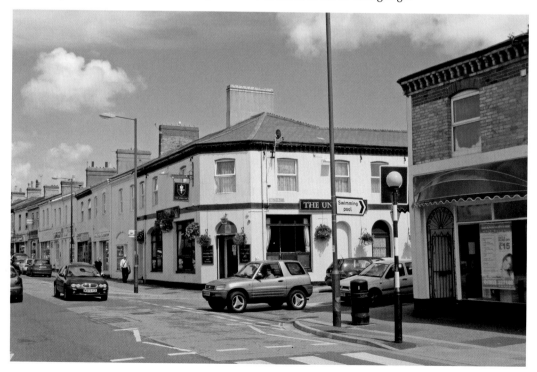

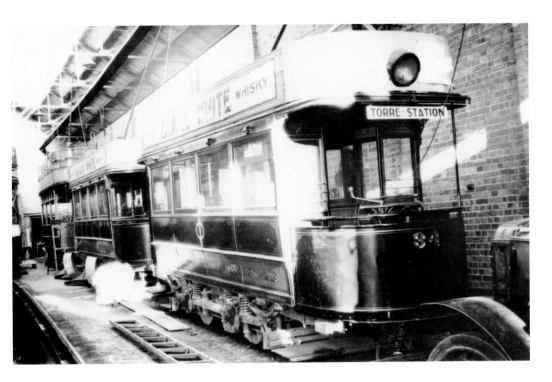

End of the Line

The main depot for the tram network was just off Westhill Avenue. It was never a very solid structure, comprising three large sheds and adjoining offices. The site is now occupied by flats and houses in the appealingly named development of 'Tramways' (*inset*), and there's a memorial to the tram system at the end of the road which is a pleasing touch.

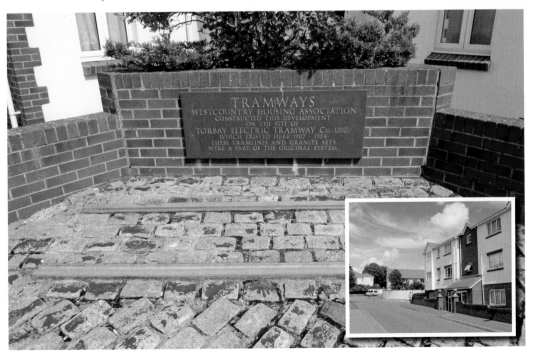

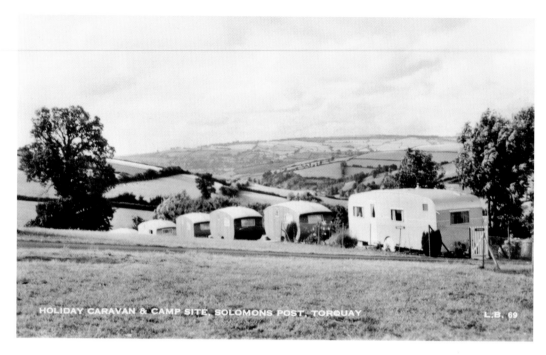

HOLIDAY CARAVAN & CAMP SITE, SOLOMONS POST, TORQUAY L.B. 69

Caravans or Cornfields?

Along Ridge Road near Solomon's Post was once a touring caravan site. Had it stayed as such it would probably still be there, but some of the caravans sprouted gardens, fences and other signs of permanence, indicating that the residents were settling down. A planning battle ensued that culminated in the closure of the site – a rare case in Torquay of a commercial site reverting to farmland, although a small part of the site was used for building.

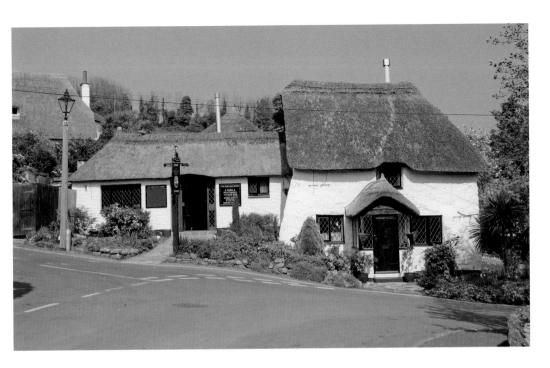

From a Farm to a Pub

Nowadays a very popular pub/restaurant (and deservedly so), the Thatched Tavern at Maidencombe has seen several transformations in its history. Originally a farm, a temporary extension assisted its conversion to the Bungalow Tea Gardens many years ago, the large grounds housing a number of shelters to protect visitors from the elements whilst enjoying their cream teas. The temporary structure has since gone, replaced by something more substantial and a lot more, dare one say, inn keeping?

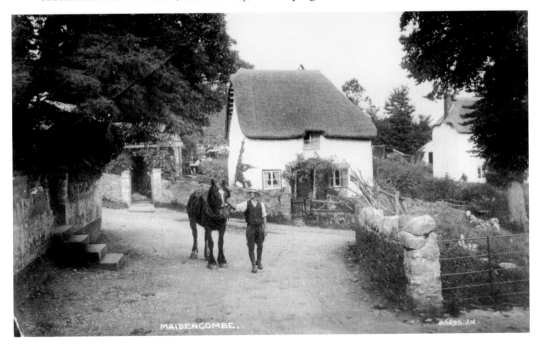

MAIDENCOMBE.

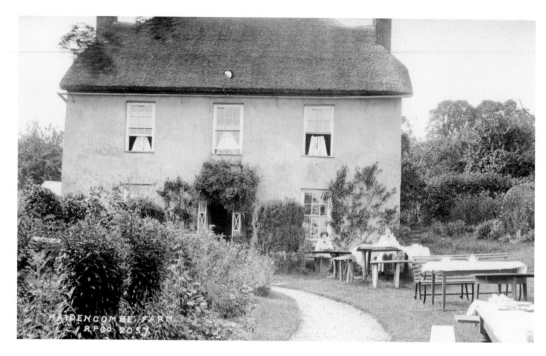

Maidencombe Farm

For many years, from the start of the twentieth century, Maidencombe Farm operated as a very popular tearoom, though I suspect that a present-day health and hygiene officer would have had a field day with the catering arrangements. The farm is no longer a tearoom, but present owners Mr and Mrs Austin (*inset*) are still very welcoming and kindly agreed to pose for the camera – with their dogs!

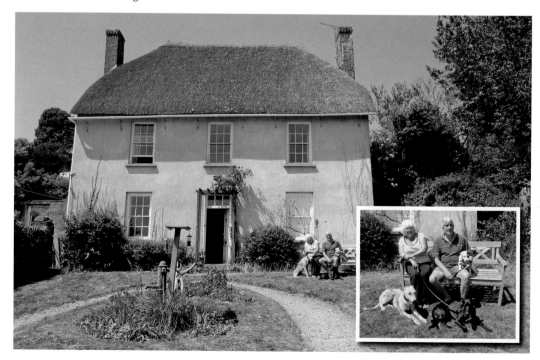

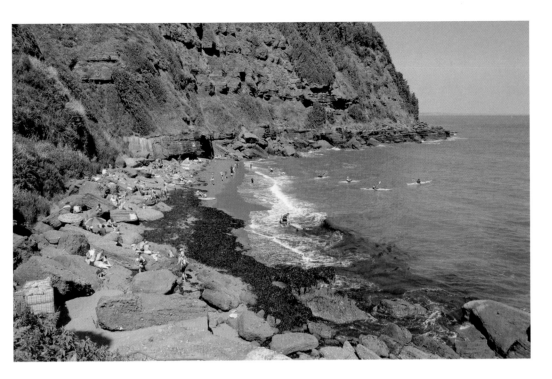

Maidencombe Beach

One of the four coves that make up the old Devonshire saying of 'Oddicombe, then Maidencombe, then Watcombe, then Babbacombe!' And if you haven't heard it before you need to split the words and add a question mark after the third name. So you get 'Odd, 'e come, then maiden come, then what come? Then babba come!' I can't recall where I first read that but I think it was in a book of local sayings published around 1890.

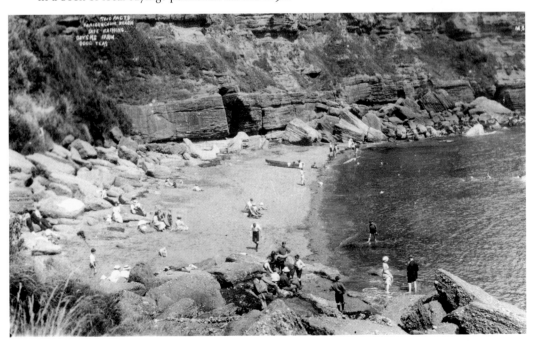

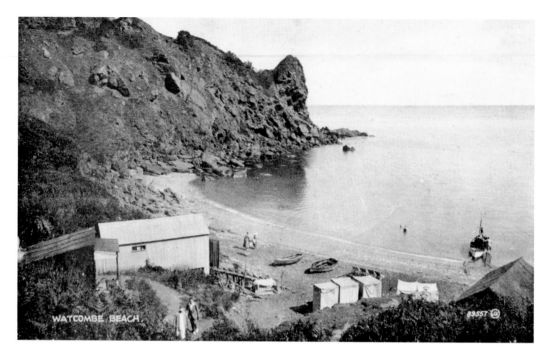

WATCOMBE BEACH

Brandy for the Parson, Baccy for the Clerk!

One of the more remote of Torquay's beaches, Watcombe Cove has genuine smuggling connections, the cove being far enough from the centre of Torquay not to attract too much attention (the nearest revenue station was at Babbacombe) and certainly not at night when small ships would bring in illicit goods from the continent. Whether such activities still take place or not, I wouldn't care to guess.

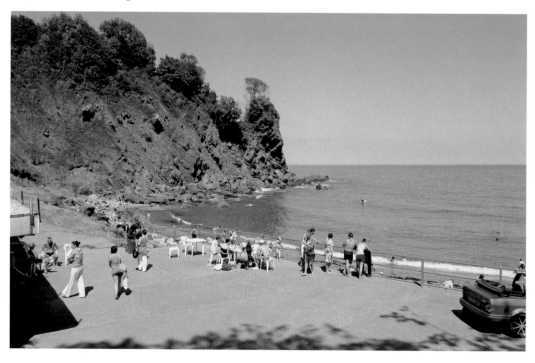

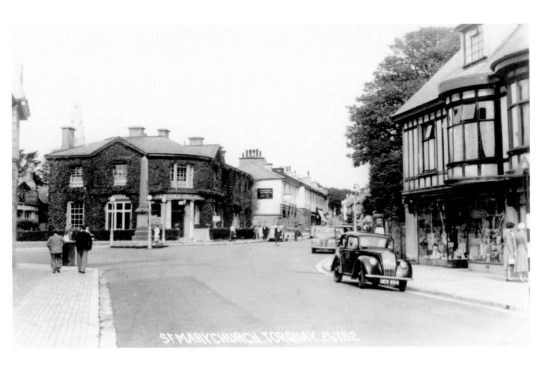

St Marychurch

The elegant architecture of the Hampton Court Hotel on the corner of St Marychurch Road and Fore Street has been demolished and replaced by a supermarket, but other than that the scene is still much as it was in earlier times, only the vehicles and the fashions marking the passage of the decades.

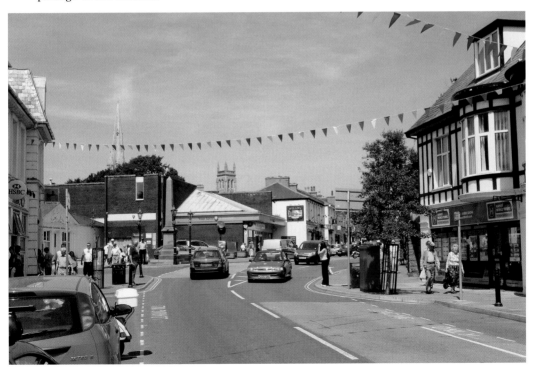

79

Manor Road

The trams had to make a sharp turn where Manor Road meets Babbacombe Road at St Marychurch, and there were several reported incidents (and presumably many that weren't!) of trams taking the corner a tad too fast so that they rocked even more than usual, and, if another tram was passing at the time, they would tend to 'nudge' each other. No injuries were ever reported but it must have been rather a frightening experience.

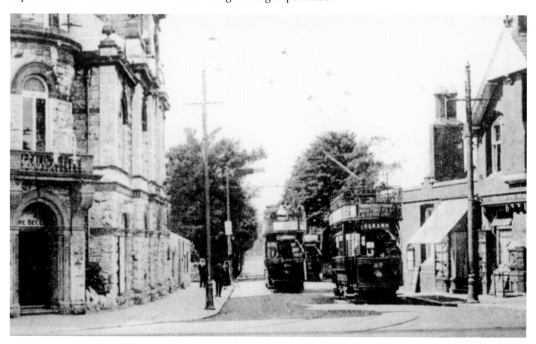

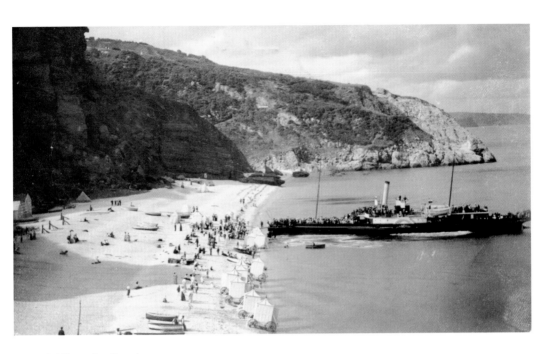

Oddicombe Beach

Edwardian holidaymakers must have been a much hardier lot than their twenty-first-century equivalents as access to Oddicombe Beach was down (and back up!) a very long and steep road prior to the opening of the Cliff Railway in 1926. In the 1905 view, the *Duchess of Devonshire* is disembarking her passengers from a cruise along the coast (possibly from Sidmouth); they may well not have realised what a climb they had in front of them.

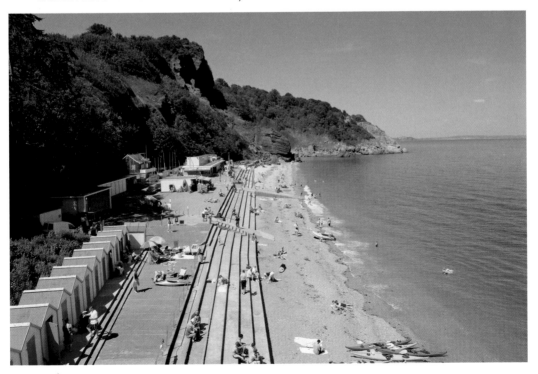

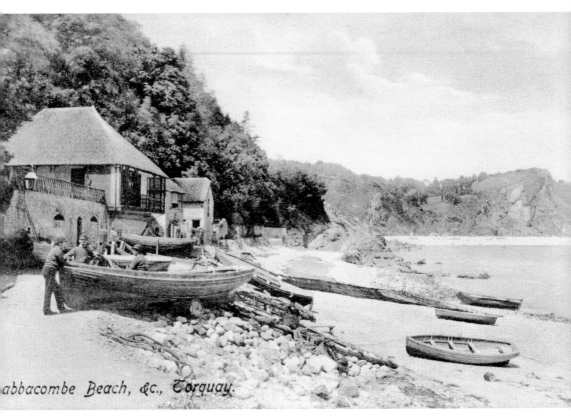

abbacombe Beach, &c., Torquay.

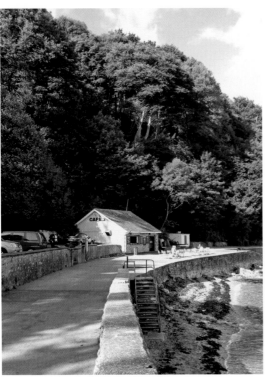

It was a Dark and Stormy Night...
This rather dull view of the beach bar and part of the car park at Babbacombe beach (left) belies the area's fascinating past. The car park was built on the site of The Glen, one-time home of Miss Emma Keyse who was murdered here in 1884 allegedly by John Lee, a member of her staff. He became famous as 'The Man They Couldn't Hang', and his story is far too well known for me to bore everyone by retelling it here. The Glen had an annexe (above) which was also demolished and the beach café now occupies the position. It's said that the ghost of the murdered Miss Keyse still haunts the site of her former home and can be seen at times falling to the ground, her throat cut and blood pouring everywhere. Do ghosts *have* blood?

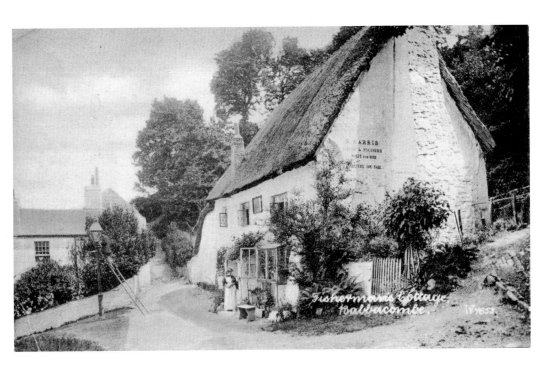

Fisherman's Cottage

Standing just above the beach, the Fisherman's Cottage formed part of the original village of Babbacombe, a small collection of dwellings down by the water. It was only much more recently that Babbacombe de-camped and planted itself at the top of the cliffs away from the threat of winter storms. I haven't discovered if the present house on the site incorporates the original cottage, but from its size and shape it appears to be a complete replacement.

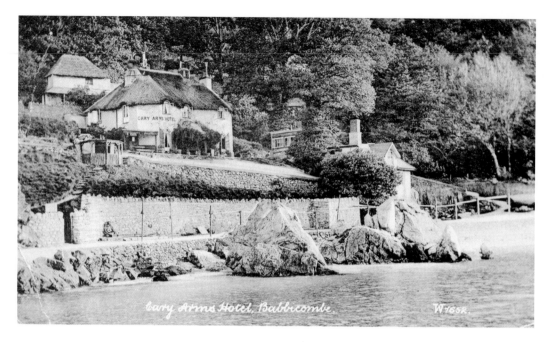

Cary Arms Hotel, Babbicombe. W1652.

Cary Arms

At its scenic best in the early evening when the sun slants across the water, Babbacombe Beach is one of Torquay's most attractive spots. The oldest part of the Cary Arms was originally thatched, but this was destroyed by fire in 1906 and replaced with a red-tiled roof, a colour it still sports today. The complex has recently had an extensive overhaul, intended to be the first stage of an upgrade of the whole area.

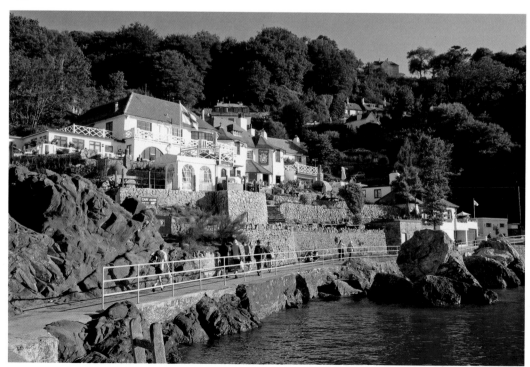

Babbacombe Downs

A pure fluke meant that a small dog ran in front of the lens as I was taking this picture. Sadly, I couldn't get him to pose in the same position as the canine in the earlier photograph, but his presence adds considerably to an otherwise very ordinary view.

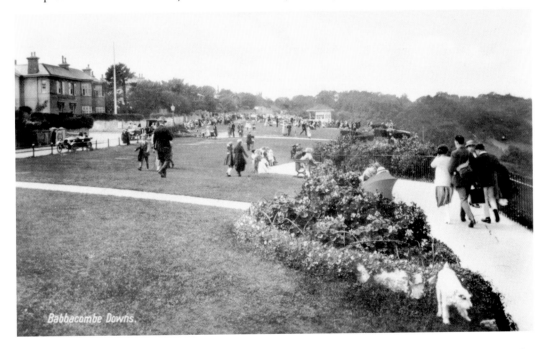

Babbacombe Downs.

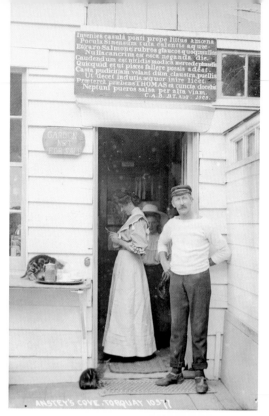

ANSTEY'S COVE, TORQUAY 10571

Anstey's Cove

For several generations, members of the Thomas family ran the beach concession at Anstey's Cove. Not content with supplying cream teas and other refreshments, they also rented out deck chairs, hired boats and bathing machines, sold fresh fish, fishing rods and other fishing items and gave swimming lessons. For some extraordinary reason, the sign advertising all these services was in Latin. Today's concession holders are Jeff Stokes and Lucy Marsh. They too provide excellent refreshments (with the menu in English, not Latin), but they don't give swimming lessons – or at least as far as I know they don't. I never actually asked them!

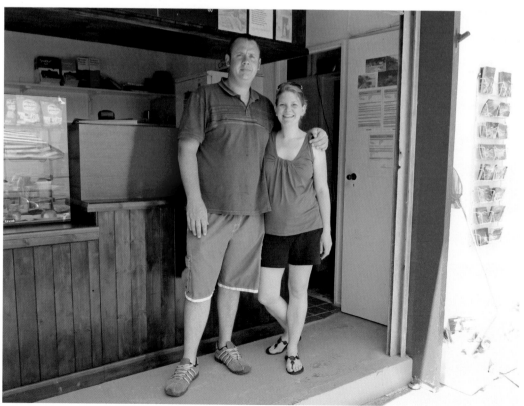

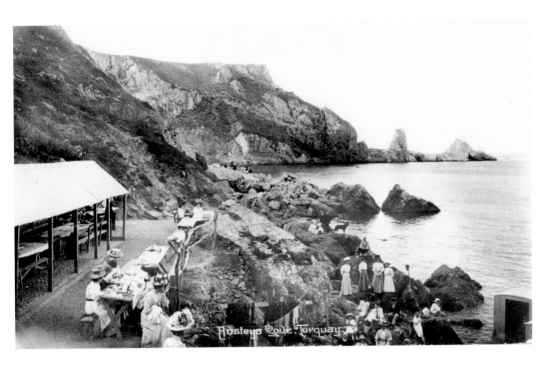

Picnics on the Beach

Anstey's Cove was the perfect destination for Torquay's genteel clientele. Its rugged character helped the great and the good arriving in their carriages to believe they were far from the civilised world. However, every amenity was available either from the beach café or from the huge hampers that were lugged by servants all the way down to the cove – and back up again when the family decided that they'd had enough of roughing it.

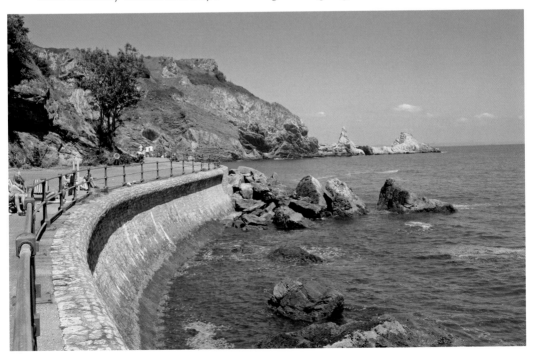

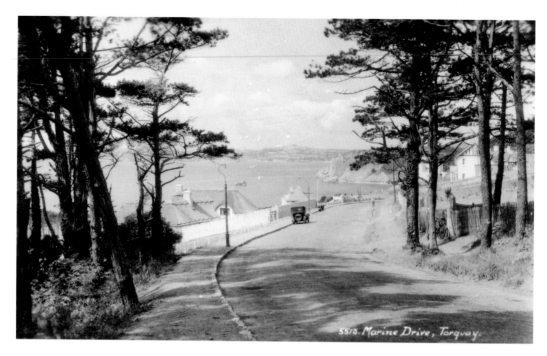

5510. Marine Drive, Torquay.

Marine Drive

The Marine Drive, Torquay's most prestigious address, was cut around the coast in 1924, partly to provide work for the unemployed. At first it was a bare road with few buildings along it, but that changed in the 1930s when several substantial houses were built, a process that continues to the present day with a number of prohibitively expensive homes taking root on the hillsides.

Anstey's Manor Hotel
The long, slow decline of the traditional two-week holiday by the seaside has meant the closure and demolition of a large number of hotels in and around the town. Those premises that stood in extensive grounds were most at risk as the sites were often worth more as building plots. Anstey's Manor Hotel is a case in point, but at least the development that replaced it has a touch of elegance about it.

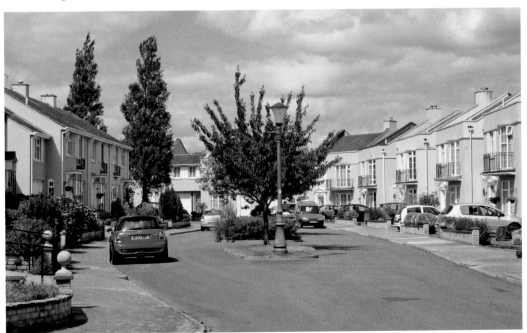

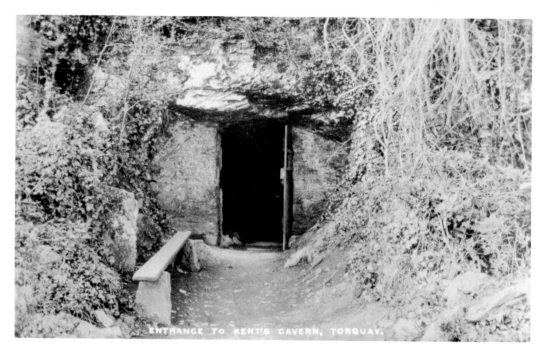

ENTRANCE TO KENT'S CAVERN, TORQUAY.

Kents Cavern

When it first opened to the public, the exterior of Kents Cavern was little more than a door and a wooden bench for visitors to park themselves on whilst waiting for a guide with an oil lamp to show them around. Under the careful guidance of several generations of the Powe family, the attraction has now grown into a thriving and much-loved institution with a world-wide reputation.

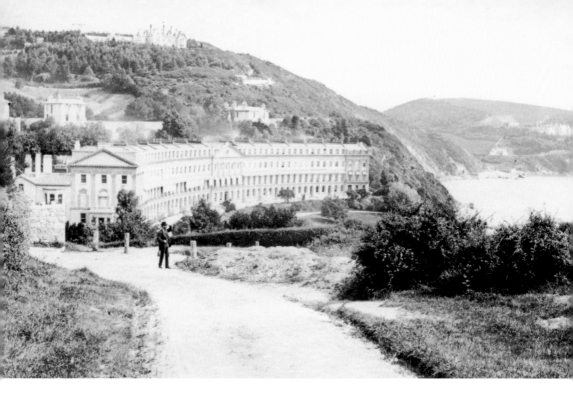

Meadfoot Beach

Another classic Torquay view is from Daddyhole Plain, looking past the grand terrace of Hesketh Crescent and along Meadfoot Beach. Totally obscured by trees today, I had to take this view from out on the headland. Only part of Hesketh Crescent is now visible though the beach view remains the same. The present-day block of flats dominating the far slopes stands on the site of Kilmorie, probably the most expensive house ever built in Torquay and the first to have triple glazed windows protecting it from the winter gales.

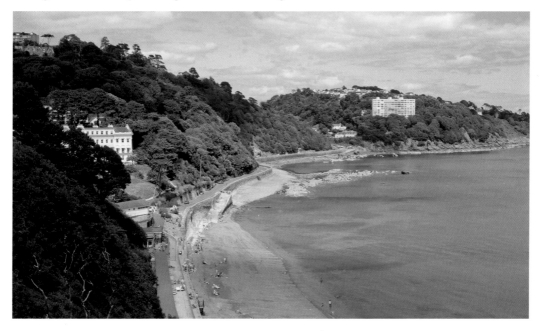

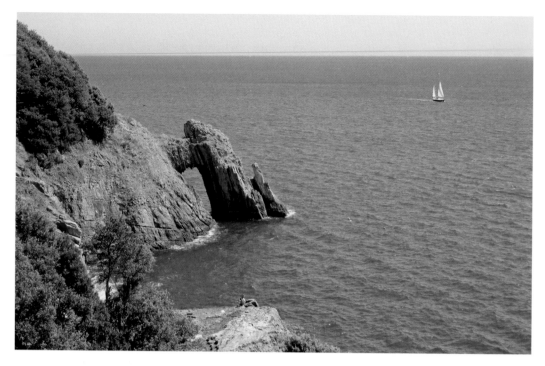

London Bridge

The natural arch that lies beyond Peaked Tor Cove is known for some vague reason as 'London Bridge'. There used to be public access across the arch itself, with railings to hang on to (no health and safety executives in those days!), but rock falls have steepened the approach so much that access is no longer possible. Once there were more of these arches locally but they've all been washed away, a fate that this one too will probably suffer in time.

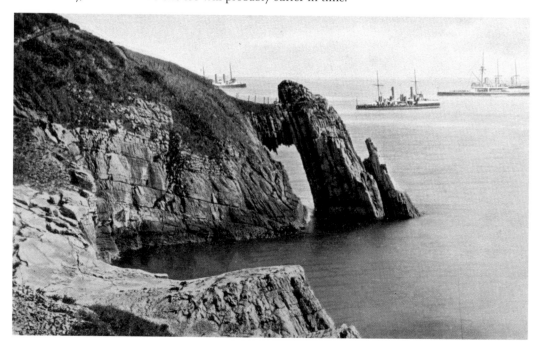

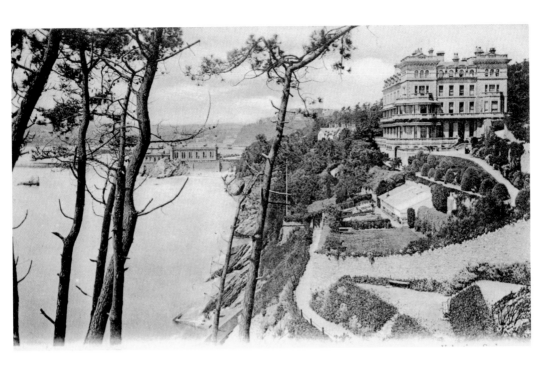

Imperial Hotel

Yet another classic shot of Torquay – the view past the Imperial Hotel towards Beacon Cove and the harbour, taken from the coastal footpath. I just could not get a clear shot of it so had to make do with a frame of trees around the picture. In the years between the shots, the Imperial (currently part of the Barceló chain) has evolved from a typically flamboyant late nineteenth-century affair to a no-nonsense modern building.

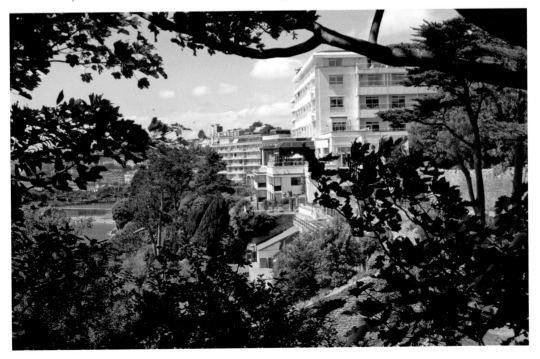

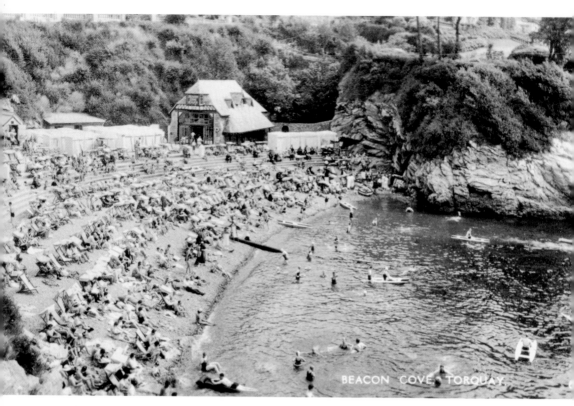

BEACON COVE TORQUAY

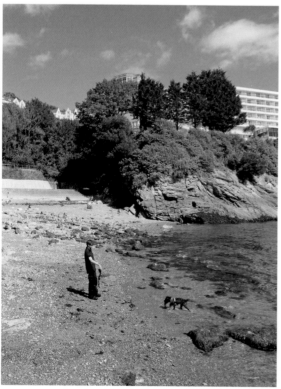

Beacon Cove

Between the Imperial Hotel and Living Coasts lies Beacon Cove, originally named the Ladies' Bathing Cove from the days when it was considered highly improper for both sexes to bathe in the same place. For generations this was known as 'the locals' beach' and was invariably packed throughout the summer. The original lifeboat station in the background did sterling duty as a café until the whole lot was dismantled when Coral Island was built, and for some years the beach could only be reached by paying an admission fee. Free public access was reinstated when Living Coasts started up but access is still not easy and the beach has yet to regain its popularity, as can be seen in the modern view, taken on a hot afternoon in mid-August!

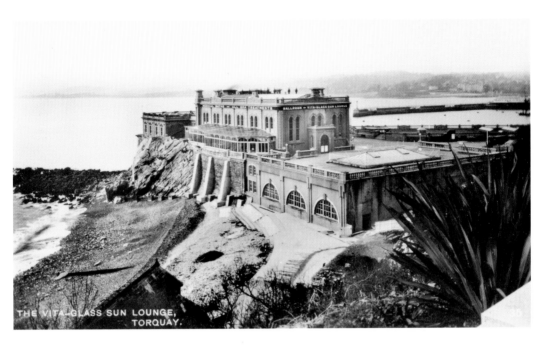

THE VITA-GLASS SUN LOUNGE,
TORQUAY.

Foxtrots or Penguins?

The much loved Marine Spa, with its ballroom and vita-glass sun lounges, finally fell victim to the bulldozer in 1971. It was replaced by Coral Island, an utterly unloved edifice that no one missed in the slightest when it too was demolished to make way for Living Coasts, the seaside arm of Paignton Zoo. The most popular of the current 'exhibits' is without doubt the penguin colony (*inset*), as they are free to wander about and mingle with the visitors.

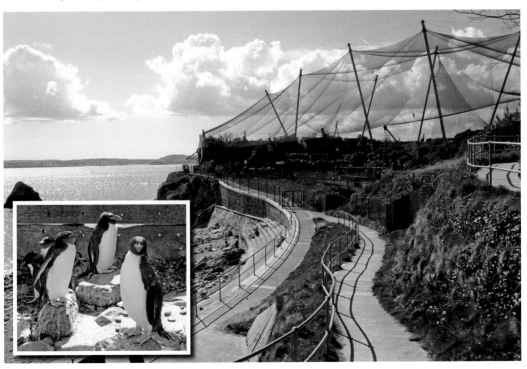

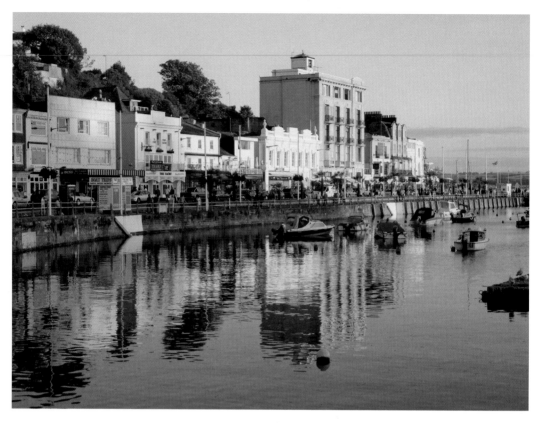

Victoria Parade
Evening sunlight slants across the inner harbour and reflects on the façades of the shops and apartments that line Victoria Parade.

Acknowledgements

Mark Pool and the Staff of the Torquay Reference Library for their unfailing help in tracking down obscure pieces of information; John Hinde (UK) Ltd for kind permission to reproduce the picture of the interior of the Islander on page 39; the English Heritage/NMR Aerofilms Collection for kind permission to reproduce the Aero Pictorial photograph (ref AFL03/AeroPictorial/R9040) of Torquay Harbour on page 5; Living Coasts for free entry to photograph the penguins; the staff at Amberley Publishing for dealing with my incessant enquiries with good natured patience; Barrie West for the generous loan of the old postcard of Fleet Street on page 29; Jane Palmer for editing, proof reading and the ruthless eradication of clichés; and finally, my thanks to all those people, known or unknown, who kindly agreed to pose and thereby add a touch of life to so many of the photographs.